THE WORLD OF JOHN BURROUGHS

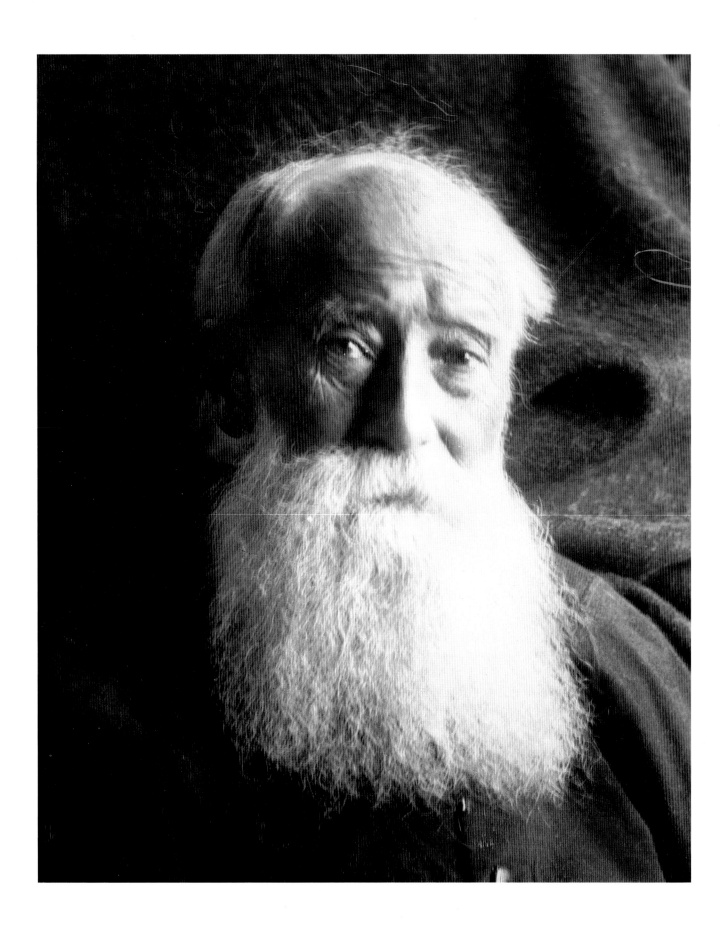

THE WORLD OF
JOHN BURROUGHS

by Edward Kanze

HARRY N. ABRAMS, INC., PUBLISHERS

For Debbie

PROJECT MANAGER: Robert Morton

EDITOR: Christine Liotta

DESIGNER: Dana Sloan

Library of Congress Cataloging-in-Publication Data
Kanze, Edward.
 The world of John Burroughs/Edward Kanze.
 p. cm.
 ISBN 0–8109–3970–3
 1. Burroughs, John, 1837–1921. 2. Authors, American—
19th century—Biography. 3. Naturalists—United States—Biography.
 I. Title.
PS1226.K29 1993
814'.4—dc20
[B] 92–45655
 CIP

Contents

Preface 7

Acknowledgments 9

Son of Farmers 12

Journeyman 36

Essayist and Grape Grower 54

Respected Man of Letters 80

An American Institution 108

Burroughs Reconsidered 142

Chronology 155

Index 157

Preface

The plain, yellowed notebooks in which John Burroughs kept a journal between 1876 and 1921 are housed in the rare manuscript collection of Vassar College, in Poughkeepsie, New York. I first read them in 1982 while researching an article on Burroughs I had been commissioned to write for *The Vassar Quarterly*.

Until then, I had known little about John Burroughs. I had not yet learned, and would not until my research was well underway, that Burroughs was an accomplished naturalist, literary critic, and philosopher; a prolific writer whose works at the turn of the century had enjoyed immense popular appeal. My scant familiarity with Burroughs stemmed from a single, unlikely source—a bronze memorial I had found during a hiking trip. It was battered by the elements, stained blue with age, and bolted to the summit of Slide Mountain, the highest peak in New York State's Catskill Mountains.

According to the plaque, Burroughs, through his writings, had made Slide Mountain known to the world. He had camped beneath the very ledge on which the plaque quoting him was mounted. It read: "Here the works of man dwindle in the heart of the southern Catskills." As I read Burroughs's words, a gray-cheeked thrush trilled delicately in the nearby woods, and wind perfumed by balsam firs roared up from the valley below. My mind filled with questions. Who was John Burroughs? What sort of man had he been, and why had someone installed a memorial to him on a remote mountaintop, miles from the nearest road? I left Slide Mountain and returned home; my curiosity had been piqued.

Years passed before my interest began to be satisfied. A coincidence had brought me to the temperature- and humidity-controlled vault at Vassar College that holds Burroughs's journals.

In ruled notebooks of the sort one would purchase in a dimestore, Burroughs had recorded his thoughts and nature observations for forty-five years. He had written in ink that trailed from his pen unevenly because it had frozen in an unheated cabin. A child had scribbled freely on the covers of several of the note-

books. Inside, the entries were compelling. There were vivid descriptions of plants and animals, long philosophical asides, encounters with great figures of the late nineteenth and early twentieth centuries, tributes to family dogs, and riveting vignettes such as a visit by President Theodore Roosevelt to Burroughs's woodland cabin "Slabsides" and a camping trip with Thomas Edison and Henry Ford. But the most affecting entries concerned everyday things such as bird sightings, rainy days, rambles in sunny meadows, domestic struggles, successes and disappointments. So fresh and immediate were the journals that I began to feel I could cross the Hudson River, walk to Slabsides, and find Burroughs alive and well, warming himself beside a fire.

In the intervals between my visits to Vassar, I read each of Burroughs's twenty-seven books. Mostly they were collections of essays, informal in tone but intellectual in temper, on such topics as the birds that nested in Burroughs's orchard, the chipmunks that inhabited his stone wall, the virtues of weeds, the geology of the Grand Canyon, the poetry of Walt Whitman, the prose of Thomas Carlyle, the meaning of life, and the secrets—as Burroughs had found

them—of happiness. The first book, *Notes on Walt Whitman as Poet and Person,* had been published at Burroughs's own expense in 1867. The last, a posthumous collection of essays entitled *The Last Harvest,* was published in 1922. The similarity between journal entries and passages in Burroughs's published works was striking. I could not imagine that any other writer had ever so fully shared his life with his readers.

My work for Vassar was soon completed, but my research into the life of John Burroughs had just begun. In the years that followed, motivated purely by curiosity and progressing with only a vague sense of where my efforts might lead, I read anything I could get my hands on by or about Burroughs—his original works, uncollected magazine pieces he had written, anthologies, biographies, tributes, book reviews, magazine stories, and several children's books. At the same time, I began to photograph plants, animals, and places that had been important to Burroughs, and to give lectures on his life and writings. It was not long before I began to see the need for a new book, a volume that would bring Burroughs to life for modern readers. Gradually, the idea for this illustrated biography took shape.

Acknowledgments

Dozens of individuals and institutions have made it possible for me to research, write, gather archival material, and produce the photographs that have gone into this book. To all of them I wish to express deep thanks.

Elizabeth Burroughs Kelley, author of *John Burroughs: Naturalist* (Devin-Adair, 1959), still lives at Riverby, the Burroughs family estate along the Hudson. From the start, she encouraged my work and provided access to documents and photographs, permission to photograph places off-limits to the public, and much general advice and assistance. Her knowledge of her grandfather's life and writings is unsurpassed by anyone. She reviewed this manuscript before it went to press.

Harriet Barrus Shatraw, of Roxbury, New York, met with me on two occasions and shared her memories of John Burroughs. As a teenager, she had spent much time with Burroughs, and it was to her that his final words were whispered. Mrs. Shatraw provided several of the black-and-white photographs which illustrate this book. Her daughter, Mrs. Jody Primoff, arranged and participated in the interviews and assisted with the reproduction of photographs.

Neil Soderstrom, a literary man of the finest sort, helped shape my idea for the book, then convinced our publisher of the project's merit. Throughout the research and writing, he provided skilled assistance as coach and critic. Joyce and Ed Kanze, my parents, housed and fed me during the period in which this volume was prepared. They typed parts of the manuscript, allowed me to fill their house with books, papers, and photographic equipment, and provided encouragement and support where they were needed.

In no particular order, I would also like to thank the following individuals: Bob Morton and Christine Liotta at Harry N. Abrams, for believing in the project; Jeff Parsons, Suzanne Lewis, and Michael Hurrell, for moral support and critical comments on the manuscript; Mrs. John Cousins and Anita Foraste, for sharing their memories of John Burroughs; Abe and Eva Hirsch, for granting me photographic access to the old Burroughs farm in Roxbury; Bill Consiglio and Dr.

Alfred Marks, for assistance in photographing Burroughs's cabin "Slabsides"; the Alsina family (especially James P. Alsina and his mother, the late Margaret Lowenthal Alsina) for housing and feeding me during photographic expeditions in the Adirondacks; Jane Smiley and Ruth Smiley of the Mohonk Mountain House, for tracking down the photo of Burroughs in the Shawangunks; Paul Huth, of the Mohonk Preserve, for guiding me to southern New York's most photogenic patch of trailing arbutus; the late Charles Dornbusch, former proprietor of the Hope Farm Bookshop, who performed feats of magic in providing me with rare Burroughs volumes; the late Katherine "Kaye" Anderson, for a gift of archival materials and years of comradery in the field; Mrs. Virginia Weinland, for help in tracking down elusive botanical subjects; Gordon Loery, of the White Memorial Foundation in Litchfield, Connecticut, for guidance in locating black-throated blue warblers; my wife, Debbie, for taking the photograph of the barn swallow while her husband answered another call of nature; Henry and Emily Koester, for hot coffee, breakfast, and permission to photograph their backyard crows on a frosty December morning; William Perkins, for generously providing me with a copy of his comprehensive (and unpublished) index to Burroughs's books and essays; Bill Urbin, for numerous tips and kindnesses; Lloyd Peterson, editor and publisher of *The John Burroughs Trail*, for research assistance and encouragement; Kurt Weiskotten and John Shull, for advice on bird-finding; Stephen Courtney, for recommending me to Vassar, and Mindy Aloff, for welcoming me there; Nicholas A. Shoumatoff, for urging me to lecture on Burroughs; Julio de la Torre, for sharing his considerable knowledge of the history of bird-watching; Frank Nicoletti, for putting a marsh hawk in my hands; and John Junker, Andy Silton, Kate Silton, Tom Meyer, Lisa Mechaley, John Van Valkenburg, and Ellie Van Valkenburg for assistance and companionship during the numerous expeditions required to produce the book's color photographs.

The institutions that deserve special thanks are listed as follows (individuals at these institutions who provided important help are noted parenthetically): Vassar College Library (Nancy MacKechnie, Lisa Browar); Library of Congress (Sam Daniel); American Museum of Natural History (Valerie Wheat); Henry W. and Albert A. Berg Manuscript Collection of the New York Public Library, Astor, Lenox and Tilden Foundations; Mohonk Mountain House; Sterling Library of Yale University; Theodore Roosevelt Collection at the Harvard University Library (Wallace Finley Dailey); Bancroft Library of the University of California, Berkeley (Annegret Ogden); Henry Ford Museum, Dearborn, Michigan (Cynthia Read-Miller); Edison National Historic Site; Thomas Edison Winter Estate Museum, Fort Myers, Florida (Robert Halgrim); Teatown Lake Reservation, Ossining, New York (Jane Darby, Marjorie Swope, Dave Fermoile); Manhattanville College Library, Purchase, New York, where much of the text was written; and Everett Studios, my photographic lab in White Plains, New York (Steven Sundlof, Barry Link, and the late George Ferris).

Any errors or omissions in the pages that follow are unintentional and the sole responsibility of the author.

"There is one American writer who stands without a peer in his own line in the whole empire of Anglo-Saxon speech. I refer to John Burroughs, the American Gilbert White."

THE QUEEN, London, circa 1910

Son of Farmers

NOrth of Manhattan Island, south of the New York State capital at Albany, and west of the Hudson River, the Catskill Mountains rise above an ancient plain. The first European settlers of the peaks, the Dutch, named them "Kaatskills" because mountain lions and bobcats hunted their steep, forested slopes, and because the valleys that crisscrossed the mountains were drained by "kills," or streams. The name was Anglicized to "Catskills" after the English took permanent control of the old New Amsterdam colony in 1674.

Today, bobcats thrive in the Catskills but mountain lions are gone. The original forests are gone too, having been cut almost to the last tree by nineteenth-century farmers, lumbermen, and tanners. In most places, a second-growth forest prevails, the new woods planted by wind, gravity, and birds. The seeds came from scattered bits of virgin forest that survived on remote peaks and in inaccessible valleys. The trees are a mix of evergreen and deciduous species such as hemlock, spruce, balsam fir, birch, beech, sugar maple, oak, ash, hickory, and several dozen others.

Geologists say that the Catskills are not genuine mountains. The grandest peaks, such as Slide (4,204 ft.) and Hunter (4,040 ft.), are admittedly mountain-like, but they were not formed by either of the two mountain-building methods that scientists deem legitimate: thrust and uplift, or volcanic action. The Catskills, it seems, were not so much created as divided. They are the stubborn remnants of an ancient plateau formed at the bottom of a prehistoric sea.

A topographic map reveals that the Catskill "mountains" are generally flat-topped, somewhat like western mesas. Their contours rise at regular intervals, like steps, because the sedimentary rocks of the old plateau which constitute them lie flat. Each Catskill peak has a unique shape, as if it were a piece of a jigsaw puzzle, because each was created by the haphazard forces of erosion.

John Burroughs was born on April 3, 1837, on the flank of a Catskill peak that local farmers called "Old Clump." At the time, Martin Van Buren, a New

OPPOSITE: *Along the red earthen road that cuts through his home farm, the young John Burroughs walked to and from a one-room schoolhouse.*

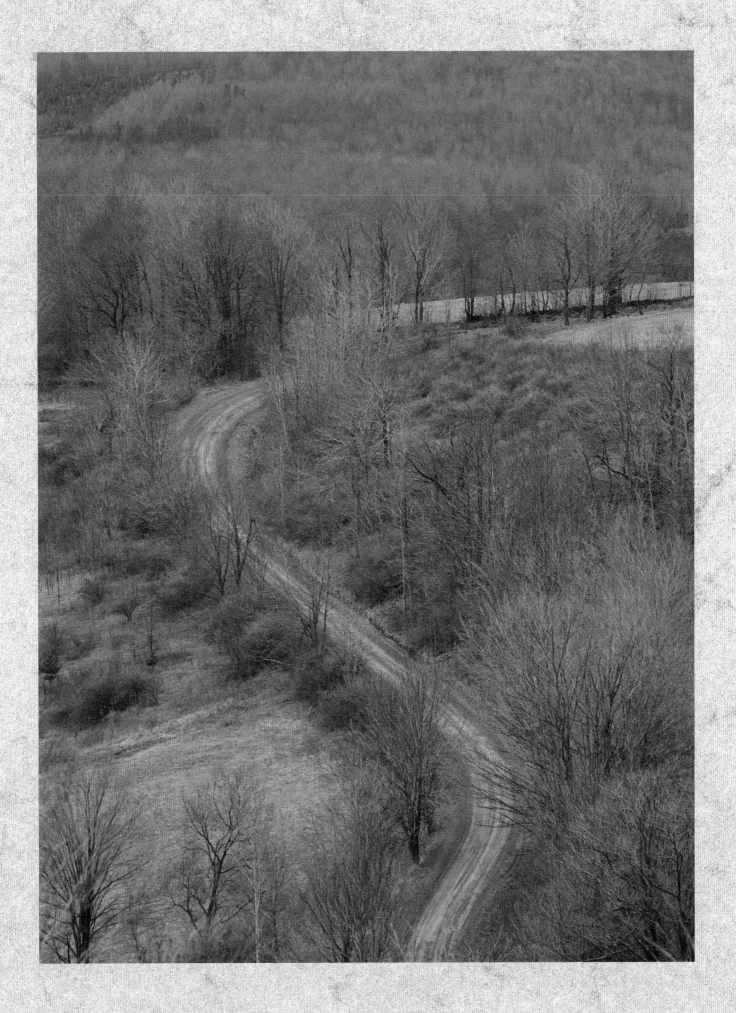

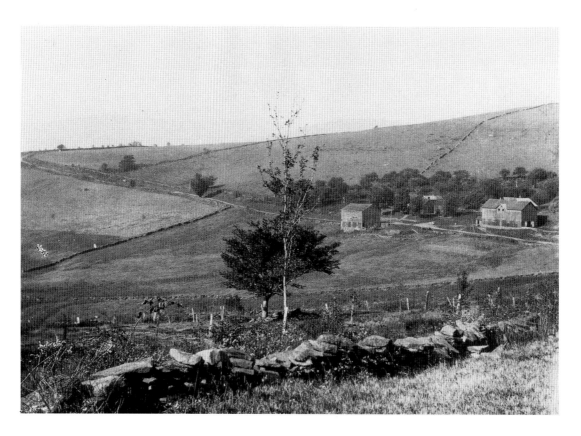

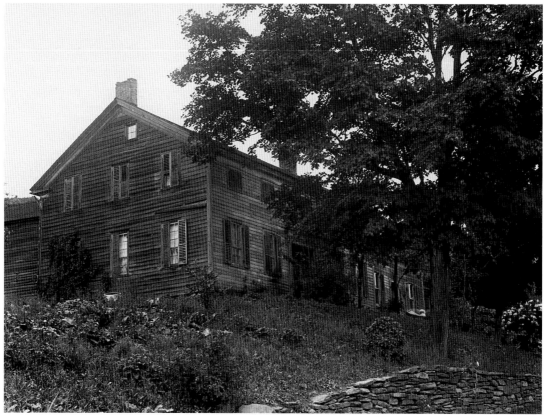

York Democrat, was President of the United States, a nation of some twenty million people. There were twenty-six states. The newest, Michigan, had entered the union only sixty-seven days earlier. That same year, on the twenty-second of October, a young Harvard man named Henry David Thoreau began keeping the journal that would one day provide the raw material for *Walden.*

Old Clump rises to a summit about three thousand feet above sea level, two miles north and east of the village of Roxbury, in Delaware County. On the southern slope, the Burroughs farm occupied some three hundred acres. By Catskill standards, Chauncey and Amy Burroughs, the parents of John Burroughs, were well off. They were rich in land, could read and write, and by virtue of hard daily toil in the open air, they were comfortable. A herd of dairy cows, a few sheep, several hogs, and field crops—chiefly hay, oats, buckwheat, potatoes, and yellow corn—satisfied most of the family's wants. Cash income came almost entirely from the sale of butter.

The son of Eden and Rachel Avery Burroughs, Chauncey Burroughs had moved to Roxbury from nearby Stamford in about 1795. Eden Burroughs was the son of Ephraim Burroughs, a Yankee farmer who had moved to the Catskills from Danbury, Connecticut, just after the Revolutionary War.

In an autobiographical account of his upbringing,

LEFT, ABOVE: The Burroughs farm near Roxbury, New York, much as it appeared during Burroughs's youth.

LEFT: In this unpainted, clapboard farmhouse near Roxbury, New York, Burroughs lived during his adolescent years. An earlier structure—the house in which he was born—had once stood on the same foundation.

John Burroughs described his father as a "noisy" and "red-haired," man who was "a good farmer, a helpful neighbor, a devoted parent and husband." Chauncey Burroughs had taught school briefly as a young man, but gave it up soon after he started and returned to the farm. By predestination, it seemed, Burroughs men became farmers.

In everything he did or didn't do, Chauncey Burroughs was serious and persistent. He refused to hunt, never picked up a fishing pole, read little beyond the Bible and newspapers, and traveled only to bring a crop to market. Providing for a family that grew to ten children, he worked long hours, six days a week, plowing, sowing, reaping, threshing, herding, haying, clearing land, digging rocks from pastures, and building stone fences. On Sundays, as the Good Book (the only book, in his view) directed, Chauncey Burroughs rested.

For Chauncey, "rest" consisted of attending the local Baptist church, reading the Bible, and arguing with neighbors. Chauncey Burroughs discussed two subjects with passion—religion and politics. In religion his feelings ran so deep that, in venting them, his cheeks often streamed with tears. The Burroughs children were not sent to Sunday school or drawn into religious rituals at home, although their father aimed to make them Baptists. As a young boy, John Burroughs loved to read. Chauncey disapproved. "He was afraid," the naturalist later recalled, ". . . that I would become a Methodist minister—his pet aversion."

In politics Chauncey Burroughs was a Democrat, a supporter of the party of Andrew Jackson, Martin Van Buren, and James Polk. Locally, he sympathized with the "Indians," a group of tenant farmers who, in the 1840s, disguised themselves as aborigines and waged a guerrilla war against their landlords. The titles to most Catskill farms—including the Burroughs place—were held by absentee landlords. (The system of land own-

John Burroughs helped his father and brothers build the stone fences that crisscross the old family farm.

ership dated to colonial days, when huge parcels of land were doled out to the English king's favorites, most of whom lived far away.) Chauncey Burroughs fed and sheltered the rebels, but he never took an active role in their cause.

Amy Kelly Burroughs, John's mother, was the daughter of Edmund Kelly, a Revolutionary War veteran who was known to his grandchildren as "Granther." Edmund had been a good soldier, and had suffered with Washington through his ordeal at Valley Forge.

He was a loving parent but only a half-hearted farmer. Whenever he could, Edmund Kelly avoided chores, fled to the woods, and fished for trout in his favorite brooks and ponds.

Compared to her father, Amy Kelly was a diligent worker. Married to the industrious Chauncey Burroughs, perhaps she had no choice. But she inherited her father's habit of escaping to the wilds. Instead of fishing for trout, she tramped into the outer fringes of the farm in search of berries and nuts. The slopes of Old Clump offered ample harvests of blueberries, huckleberries, and chestnuts, and Amy collected them gladly whenever she could.

From his mother, the only one in the immediate family who seemed to share and appreciate her son's attraction to wild places, John Burroughs inherited much. To a friend he once explained: "I owe to Mother my temperament, my love of Nature, my brooding, introspective habit of mind—all those things which in a literary man give atmosphere to his work. . . . My idealism, my romantic tendencies, are largely her gift."

Chauncey Burroughs and Amy Kelly met in a schoolroom. He was the schoolmaster, she his pupil. Chauncey was five years older. They courted, married, and shortly afterward moved to the farm that became their lifelong home.

John was the seventh child born to Chauncey and Amy Burroughs. He entered the world with three brothers, Hiram, Wilson, and Curtis; and two sisters, Olly Ann and Jane. A sixth sibling, a boy named Edmund, had died as a baby. Chauncey was thirty-five, Amy twenty-nine.

In such a big family, John never lacked for bunkmates. Sleeping two or three to a bed was the family rule, and in winter the arrangement was undoubtedly a blessing. The wooden house, like most in that era and locale, was uninsulated and drafty, and most of it was

Cows no longer graze on the old Burroughs farm in Roxbury, but the fields are still mowed for hay.

unheated except for special occasions. Only the kitchen was dependably warm.

The Burroughs's kitchen was a comfortable, inviting place, as much a room for dining, gossiping, and passing time as for preparing meals. A big wood-burning cookstove kept the kitchen toasty in winter, even when the temperature outdoors fell below zero. The room included an open fireplace (in which John's mother had cooked before the stove arrived) with a beehive oven for baking bread.

The farm and its woodlots provided nearly all of the family's needs—food, fuel for cooking and heating, clothing, and candles. Split lengths of maple, beech, and birch were fed into the cookstove. The Burroughs boys shared the job of bringing the wood inside and stacking it behind the stove in the unused fireplace, where it would dry. As an old man, John recalled that he had piled the wood high in the mouth of the fireplace so that his father would think the deep space behind it was filled. Although Chauncey was not always fooled, he was more bark than bite. For the Burroughs children, physical punishment was rare.

The diet of the family consisted largely of dairy products. Chauncey kept Durham cows, the herd usually numbering about thirty head. From the cows came the farm's chief cash crop, butter, which the family consumed in great quantity, year-round. Milk was a staple beverage, cheese a daily food, and cream a favorite with berries and desserts.

The cattle also supplied the family's beef. Each winter, Chauncey would kill an unproductive cow or a bull and hang it in the milk house. He also slaughtered six or seven pigs every autumn. The carcasses provided pork and bacon, fat for making soap, and tallow for dipping candles.

The Burroughses were not strictly red meat and dairy eaters. They also ate eggs, poultry, and wild game such as ruffed grouse (they called it "partridge"), squirrels, and passenger pigeons. Their orchard provided apples, and in season the woodlots supplied maple sugar and the honey of wild bees.

In the fields with the most easily tillable soil, Chauncey grew rye, corn, oats, and buckwheat. Amy served the grains to her family in several forms—as porridges, puddings, cakes, breads, and griddle cakes.

The Burroughses grew clothing, too. From flax plants, Amy collected fibers, spun them into strong thread, and wove the thread into cloth. As an old man, John Burroughs recalled the homemade flax shirts and trousers of his childhood as hard, rough, and durable.

The family also kept just enough sheep to provide wool for clothing and carpets. Each June, Chauncey and the older boys drove the sheep into a nearby stream and washed them. Then the sheep were sheared. Amy twirled the wool into yarn on a spinning wheel, then wove it into fabric on a loom which was kept, as John once recalled, in a barn, "in the hog-pen chamber."

In this world of cows, pastures, woodlands, meadows, toil, wholesome food, plain clothes, and hard-earned rest, John Burroughs grew to manhood. Each day on the Burroughs farm began at five. Before the sun had appeared, the children would rise, dress, perhaps visit a wash basin and splash their faces with soap and cold water, and clump downstairs to the kitchen. There, on a typical morning, they would find their mother stoking the cookstove, readying it for breakfast. But breakfast did not come at once. As soon as he was old enough to assist with outdoor chores, John would shuffle out the door, tramp down the lane to the barn, and, with the help of the other young boys, turn the cows out to pasture. On the Burroughs farm, the herd breakfasted before the herders.

Breakfast was served at six, by candlelight. On a

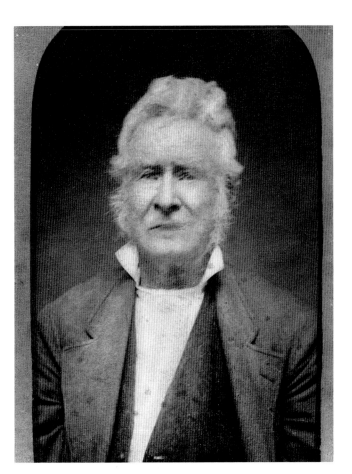

Chauncey Burroughs.

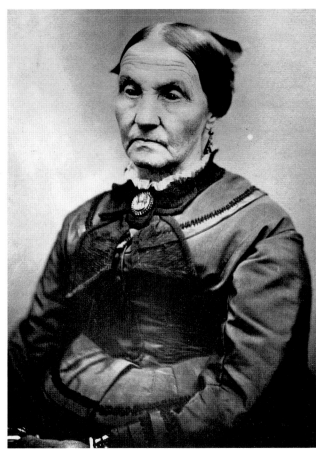

Amy Kelly Burroughs.

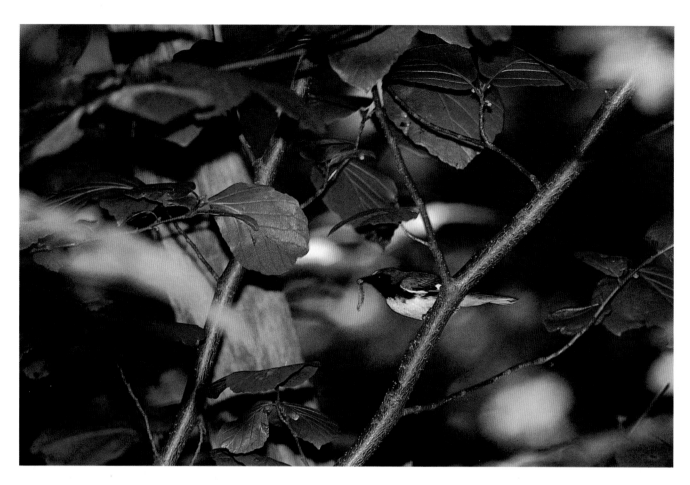

ABOVE: A black-throated blue warbler holds a moth larva gleaned from a leaf. Burroughs was the first to find and describe the black-throated blue warbler's nest.

RIGHT: Burroughs and his friends sometimes stole away from school to swim and fish at Stratton Falls near Roxbury. To justify their misbehavior in the eyes of the schoolmaster, the boys dug slate from the hillside and whittled narrow pieces of it into pencils. In his old age, Burroughs sometimes brought friends to the falls for picnics.

LEFT: Basswood trees grew in the woodlots of the Burroughs family farm in Roxbury.

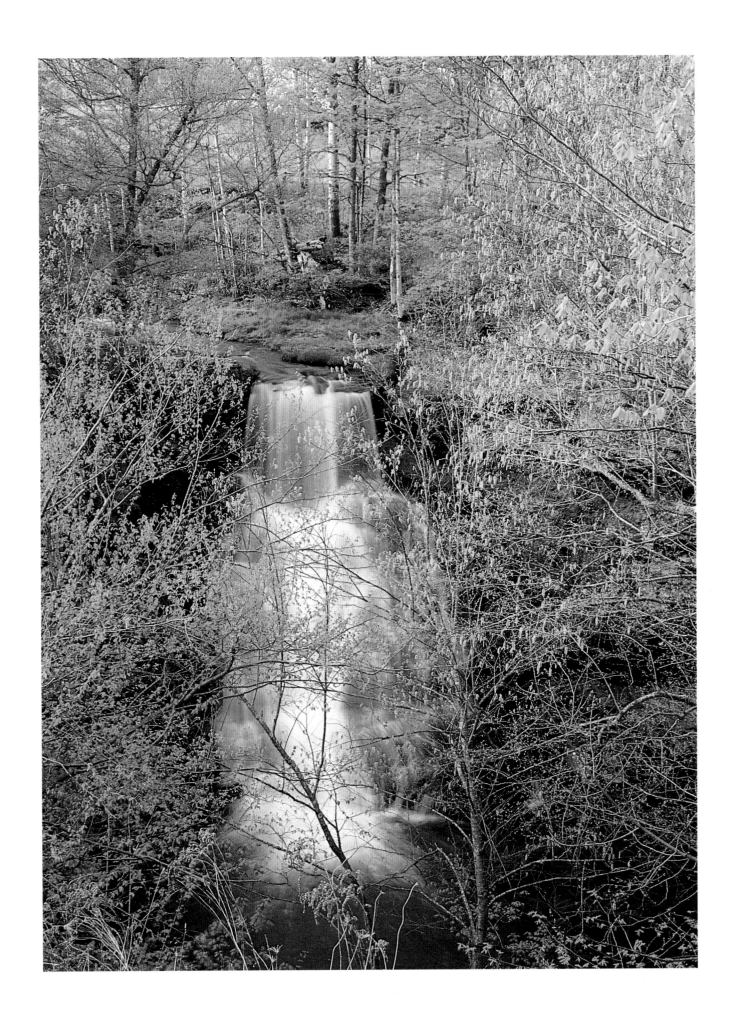

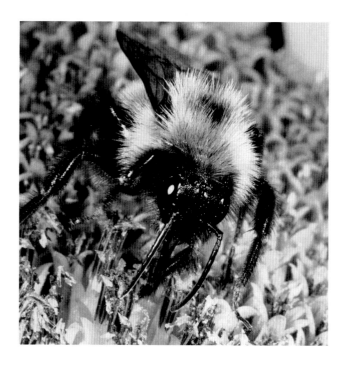

John Burroughs considered the time he collected a jar of bumblebee honey as one of the great triumphs of his boyhood. Bumblebees make little honey compared to honeybees, and their ground nests are not easily found or raided.

cool morning, the big kitchen would be comfortably warm by then, and here the family would gather around a wooden table. The meal was always filling. Typical fare included pancakes, maple syrup, bacon, homemade bread, butter, and hot oatmeal porridge.

After breakfast the day began in earnest. In his early years, between the ages of about five and ten, John trekked down the road to a one-room schoolhouse every autumn, winter, and spring. During the summers, he helped his mother, sisters, and the other young boys with household chores and butter-making. In the warm months, Amy served three meals after breakfast: at ten, lunch to the men and older boys in the fields; at noon, dinner back at the house; and at five, supper. Bedtime came early, usually at eight. This was an era before the advent of radio and the gramophone.

Every autumn, the Burroughs boys were assigned a special seasonal chore—marching through the fields with long sticks to knock apart cow droppings. It was great sport. In *My Boyhood* (an autobiography of his early years), John likened this favorite chore to golfing. Perhaps not by coincidence, at the age of sixty-eight, he swung a golf club for the first time on a course in Ridgefield, Connecticut, and shot a good game. Burroughs wrote to a friend shortly afterward, "Yesterday I played my first game of golf and beat one old player, and tied another. You may hear of me as a champion golf player!"

When not attending school, and before he was robust enough for the hard labor his father demanded of the older boys, young John Burroughs helped his mother make butter. The process involved several steps. First, the cows were herded into the lane in front of the house, where they were milked by the adults and older children. Next, the milk was carried into a milk house and poured into iron pans that sat on a wooden rack.

By mid-afternoon in warm weather, the milk

would "clabber," or curdle. Now it was ready for skimming. Amy Burroughs used a knife to part the cream from the sides of the pan, and then, tilting the vessel, she poured the semi-viscous fluid into a cream pan. To Catskill farmers like the Burroughses, cream was a valued commodity. Converted to butter, it could be kept for months—long enough to be accumulated in kegs and brought to a distant town, twice a year, to market. Milk, by contrast, spoiled quickly and was largely a waste product. After a small portion had been set aside for family consumption, the bulk of the milk was dumped into a swill barrel and fed to the pigs.

Churning the butter was hard work. In winter, and during the first months of spring, cream production was light, and Amy and her helpers made the butter the hard way, in a hand-churn. During the seasons when cream was abundant, it was put into a big mechanical churn powered by a sheep or dog. The animal—often with "encouragement" from the children—would plod in circles for hours, and the cream would be agitated. Sheep, Burroughs recalled in his autobiography, made better workers than dogs. Dogs were often smart enough to hide when the time for butter-making arrived.

After the butter had "come," John's mother removed it from the churn and washed away the buttermilk. Now the butter was packed. Spring butter was put up in fifty-pound tubs. In summer, butter was packed in 100-pound wooden barrels called firkins.

In the company of his oldest sister, Olly Ann, John Burroughs made his first mile-and-a-half walk to school at the age of about four or five. School took place in a one-room stone structure known as the "Old Stone Jug." Here John mastered the alphabet, and here also he took up a lively interest in the opposite sex. To amuse himself, Burroughs confessed later in his autobiography, he would crawl under his desk and tickle the ankles of the girls with a feather. "I was fond of the girls back as early as I can remember," he once told a friend, "and had my sweethearts at a very early age."

After two years at the Old Stone Jug, Burroughs attended another school—a wooden structure, newer and more comfortable than the Jug, in a place known as the West Settlement. The West Settlement School provided most of Burroughs's formal education. Inside the little red building an innovation known as the blackboard hung on the wall. Outside, a brook flowed past the play yard. An eager student, Burroughs quickly developed a love for books, for ideas, and for the world that lay beyond his valley.

Young John Burroughs enjoyed his lessons, at least for the most part, but found recess the highlight of any day. In good weather, lunchtime was spent outdoors. All the children brought "dinner baskets," and in his John often found rye bread, butter, a piece of pie or cake, and some apples. Sometimes, he supplemented a meal with wild berries, nuts, or the spicy root of the toothwort, or crinkle-root, that he collected in the woods and fields near the schoolhouse.

Play followed. In the warm months, the boys swam in the brook flowing past the school. Occasionally, when the day was sunny and warm, John and his friends extended their lunch hour by playing hooky. This usually meant an expedition to Stratton Falls, several miles away. Here the boys would swim and, to justify their absence to the schoolmaster, dig pieces of soft rock from a cliff and carve them into pencils.

For Burroughs, the most welcome diversions from schooling, aside from chances to misbehave, were books. Unlike his brothers and sisters, he read hungrily and soon borrowed books from the district library. A

NEXT PAGES: *In the soft light of an autumn dawn, a great blue heron hunts for its breakfast.*

23

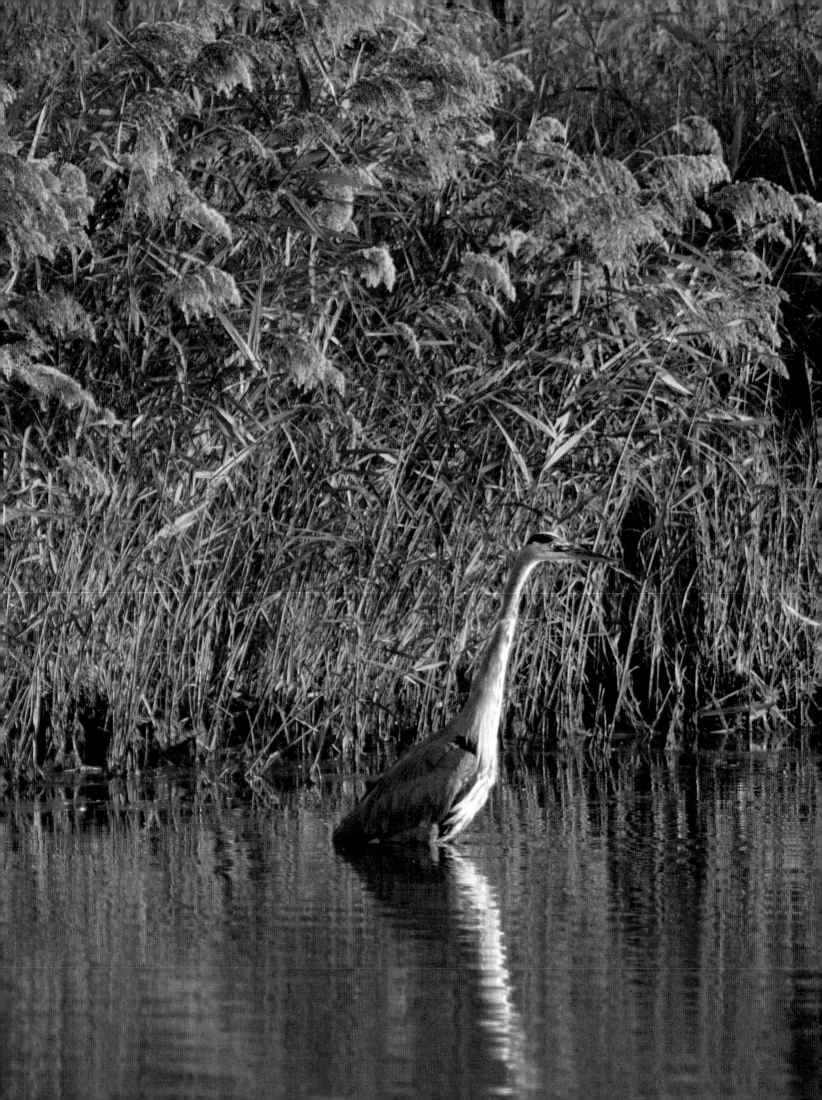

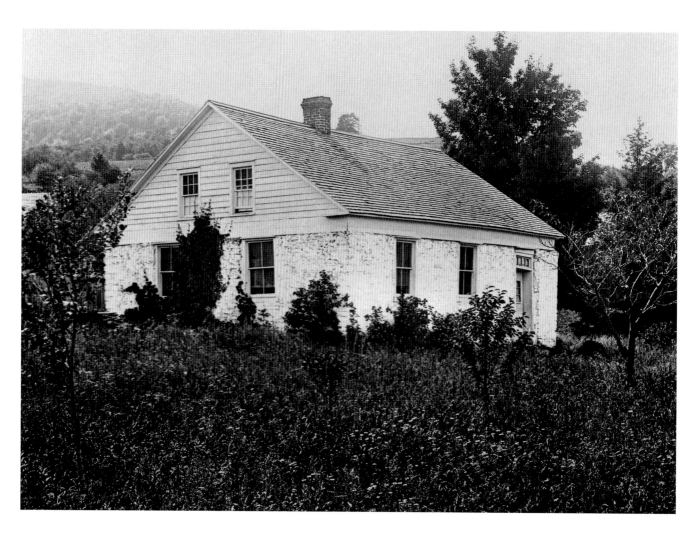

Burroughs's first schoolhouse, known as the "Old Stone Jug."

favorite volume was a biography of George Washington. Books brought the young Burroughs words, and words gave him pleasure.

Getting home from the West Settlement School required an uphill walk of two miles by road, or one mile by shortcut. Either way, John Burroughs faced a challenge he would rather have avoided—passing a small cemetery at a bend in the road. The challenge was especially daunting in winter, when he walked home after sunset. "If I had to pass the burying ground up on the hill by the roadside in the dark," he wrote in *My Boyhood*, "I did so very gingerly. I was too scared to run for fear the ghosts of all the dead buried there would be at my heels."

On Sundays, during his hours of leisure, John Burroughs wandered in the countryside alone, with his friends or brothers, or with a favorite dog. He explained as an old man, "As a youth, I never went to Sunday school. . . . My Sundays were spent rather roaming in the woods and fields, or climbing to Old Clump, or, in summer, following the streams and swimming in the pools." He also went fishing, although this activity, frowned on by Baptists on the Sabbath, brought "parental displeasure—unless I brought home some fine trout."

On fishing expeditions, his favorite companion was his mother's father, Granther Kelly. Granther was a skilled and passionate trout fisherman. He lived only a few miles away, and often came "over the hill" to take John along on his visits to local fishing holes. John learned much from his grandfather, including his fear of ghosts. Granther was genuinely terrified of "spooks."

The Burroughs children had no store-bought toys. Except perhaps for a few hand-me-downs, they owned only playthings they made themselves. Among the boys, the stand-bys were sleds and slingshots. In this

John Burroughs, all his life a farmer, never learned to appreciate the woodchuck—except skinned, roasted, and served on a dinner plate.

Blue flag irises flourish in freshwater marshes. Burroughs advised readers to seek excitement in the commonplace, not only to search for the rare and exotic.

BELOW: *Wild columbine. Burroughs was glad that he would never learn all of the wildflowers in his home woods; there would always be new discoveries.*

OPPOSITE: *Young Burroughs fished for trout in this, and other, Roxbury streams. He recalled in* Signs and Seasons, *"The little brown brooks,—how swift and full they ran! . . . One's thoughts and sympathies are set flowing by them; they unlock a fountain of pleasant fancies and associations in one's memory; the imagination is touched and refreshed."*

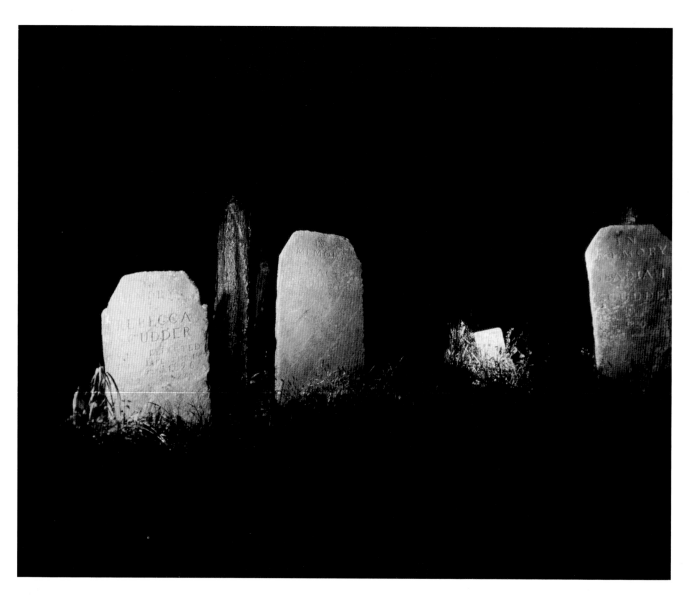

As a boy, Burroughs feared nothing more than passing
this old cemetery at a bend in the road after nightfall.

do-it-yourself environment, John Burroughs found and developed his interest in natural history. His interest cannot be traced to a single source—there were no naturalists in the family, and no self-taught or formally educated scholars. But there was a grandfather who enjoyed taking him fishing, and a mother fond of berrying. There were woods and fields rich in plant and animal life, and many free hours in which to think and learn and explore.

In quiet moments, when alone or accompanied only by a dog, Burroughs liked to sit on a boulder in a far pasture. There he gazed across a series of fields to the mountains beyond. And if it was March or early April, he could watch the smoke rising into the sky from Seymour Older's maple-sugaring camp. Closer at hand was a beech woods. Here, on an April day, he might find "the naked spring woods gay and festive" with the "soft voices and fluttering blue wings" of passenger pigeons. They advanced through the beeches "like a blue wave," Burroughs recalled after the birds had vanished forever, "those in the rear . . . flying over those in front, so that the effect was that of a vast billow of mingled white and blue and brown."

When looking back over his life from the vantage point of old age, Burroughs traced his lifelong passion for birds to the day he first saw a black-throated blue warbler, a tiny, migratory, insect-eating songbird with a blue back and an ebony mask and bib, that summers in North American forests. One day, while exploring a woodlot on the farm, Burroughs spotted a black-throated blue. He was startled—it was such a pretty thing, so dainty, so elegantly marked, that it struck him as exotic in woods where he was used to seeing only common species such as robins and sparrows. To young Burroughs, the moment was galvanizing. The pursuit and study of birds became abiding pleasures.

As Burroughs grew, gaining height and muscle as well as an expanded intellect, numerous changes occurred in his daily routine. At about the age of ten, he was assigned to join his brothers in milking the cows. Now he had less time for favorite exploits such as finding the subterranean nests of bumblebees and collecting their honey. Soon, mornings and evenings, he was helping to put the herd in and out of the barn and, in winter, to supply the animals with fodder. When a sheep or dog could not be found to operate the butter churn, he sometimes found himself in the harness. For older boys, attending school was a luxury reserved only for winter. Farm work beckoned and

In later years, mourning doves reminded Burroughs of their extinct relations, the passenger pigeons, that once visited the beech woods on his father's farm in huge flocks.

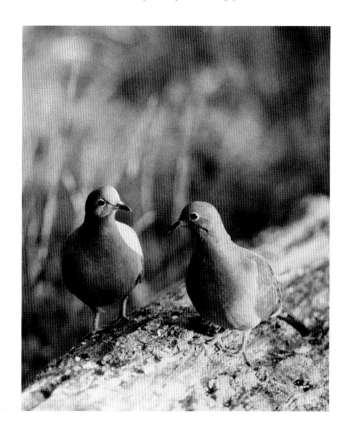

A meadow lies buried beneath ice and snow. "A snow-
covered plain," wrote Burroughs, "is the face of death;
yet snow is but the mask of life-giving rain; it, too, is the
friend of man,—the tender, sculpturesque, immaculate,
warming, fertilizing snow."

John joined his father and older brothers with chores such as spreading manure, sowing, reaping, haying, threshing, building walls, and cutting wood.

Each fall, a butter buyer named Dowie appeared at the Burroughs farm on horseback. With a special tool, he extracted cores of butter from deep in the firkins and sniffed them. The fresher the butter, the more it pleased Dowie's nose, and the higher the price a farmer received. It was a source of family pride that Burroughs butter was generally of good quality and fetched eighteen to twenty cents per pound. After the testing, a schedule of delivery would be agreed upon. Usually the dates fell in November. A lumber wagon would be loaded with twenty or more firkins and then driven fifty miles to the village of Catskill, on the Hudson River. The journey took four days there and back, and two round trips were needed.

John looked forward to his first butter trip eagerly. He would spend three nights in taverns, see places and meet people his older brothers had been telling him about for years, and get his first look at the great Hudson River. With luck, he might even glimpse a steamboat. For a Burroughs boy on the verge of adolescence, it was a solemn rite of manhood to join Chauncey on the autumn butter trip. Thus, at the age of eleven or twelve, John made his first lengthy journey out of the valley. On a crisp November morning, Chauncey and John rumbled down the lane. Apart from the heavy firkins, the wagon was loaded with oats for the horses and a box of food for Chauncey and John which Amy Burroughs had packed with fresh bread, butter, beans, gingerbread, maple sugar cakes, and meat—usually including some wild game such as partridge, wild pigeon, and squirrel.

They spent the first night at the halfway point, Steel's Tavern, in Greene County. In the morning the journey resumed. Slowly the wagon progressed, rumbling toward the river, and by late afternoon the village of Catskill had been reached. Chauncey and John delivered their cargo to the buyer and took payment in cash. Before dark, John got his first glimpse of the Hudson, saw a steamboat, and heard the whistle of a railroad train. He felt like a man of the world.

At home, John Burroughs's life continued to change. The old house—the familiar dwelling in which he had grown from infancy—was dragged into the orchard by teams of oxen, and a new house, bigger and sided with clapboards, was put up in its place. (This house still stands today.) He became an expert at mowing hay with a scythe. And now his father encouraged him to roam with a rifle—not to hunt for meat, but to shoot animals that farmers considered pests. These included chipmunks, woodchucks, raccoons, crows, hawks, owls, and foxes. Later in life, Burroughs remembered much of this shooting with chagrin. He was especially troubled by the recollection of killing six fledgling screech owls which he had found side by side on a branch. "Oh, boys are savages!" he wrote in *My Boyhood.* "They don't dread to shed blood. They delight in it."

Burroughs's teenage years had a gentle side. His interest in girls grew. Until he was thirteen or fourteen, a neighbor, Eleanor, was a favorite. Boys and girls often got together at chaperoned parties. The social events Burroughs enjoyed most were autumn apple-cutting bees which were held after dark at Roxbury farmhouses. Teenagers would arrive from far and wide. At seven, usually in the kitchen, they would begin to cut and peel. It was serious work, but there was much talk and laughter. At about nine, the host would declare the job completed. Then pies and drinks were served, games played, and flirtations pursued. Afterward, the boys walked their favorite girls home. For Burroughs, getting home with or without a female companion usually

required passing the old cemetery at the bend in the road. Fortunately, as his social horizon expanded, his fear of ghosts evaporated. Soon he could pass the graves "in the little hours" of the morning "without a tremor."

A young man with independent interests requires an independent income. Burroughs earned pocket money making maple sugar. Each March, a week or two before he helped his father and brothers tap 250 or so big maples, Burroughs would tap four or five smaller trees. He carved his own spiles, or taps, out of basswood and drove them into holes that he drilled at the lower ends of three- or four-inch gashes—cut with an iron gouge—in the trunks. Sap would ooze out of the gashes, pour down the spiles, and drip into open pans. Burroughs carried the sap to the kitchen, boiled it on the cookstove over a wood fire, and poured the resulting condensed sugar into cake molds. Early

season sap is generally light in color—the highest commercial grade—so the young entrepreneur was able to sell his cakes in the village for as much as two cents apiece. "Those lucid March days in the naked maple woods under the blue sky," Burroughs wrote in his autobiography, "with the first drops of sap ringing in the pans, had a charm that does not fade from my mind."

With the money Burroughs earned in the sugar bush, he bought books. He eagerly read every volume, and each heightened his awareness of other works that he had not read. He began to long for friends with whom to share his interests and ideas; people with a similar appetite for history and philosophy and nature. Among his relations and schoolmates he could find none. To meet kindred spirits, Burroughs would have to leave Roxbury and venture into the world.

Several of the sugar maples that Burroughs tapped for sugar-making still stand on the old family farm. This ancient specimen grows near the Burroughs homestead.

Journeyman

Shortly before his seventeenth birthday, John Burroughs packed a black oilcloth satchel with a few belongings, said good-bye to his family, and took to the road. On foot, and later by stagecoach, he traveled until he arrived at Olive, a village in the eastern Catskills. There he looked up Dr. Abram Hull, an old family friend.

Dr. Hull helped Burroughs find his first salaried job—teaching in a one-room schoolhouse, much like the one John himself had recently attended, in the nearby village of Tongore. The citizens of Tongore supplemented the new schoolmaster's pay by inviting him to eat and sleep in the houses of students and their families.

On the thirtieth of May, 1854, John Burroughs began to make notes in a pocket-sized writing tablet. He recorded expenses—for a hat, a coat, three books, and hiring a fiddler—and set down thoughts in a florid prose. "Courage is a plant of tropical growth," he wrote in one entry, "and will not flourish in a soil of semi-starvation or in the frozen zones of poverty." Burroughs had few material resources, but he was a young man of strong resolve and high ambition. He needed an opportunity.

Burroughs worked hard and lived frugally, and having no wife or family to support, he was able to save most of his salary. Late in the year, he resigned his job as schoolmaster to enroll in a three-month course of study at the Hedding Literary Institute, a small private school in the Catskill village of Ashland. At Hedding, during the cold mountain winter, he learned algebra, geometry, grammar, chemistry, logic, and French. He slept in a cramped dormitory with three hundred fellow students.

Although Burroughs enjoyed his term at the Institute, low finances forced him to leave the following spring and look for a job. Boarding a train for the first time in his life, he traveled to New Jersey in hopes of finding a teaching post.

The search turned up nothing. Disappointed, Burroughs returned to Roxbury and spent the summer of 1855 haying and milking on the "home farm," as he called it. But he had no interest in remaining a man of the soil. In the autumn,

"It would not be easy to say which is our finest or most beautiful wildflower," wrote John Burroughs, *"but certainly the most poetic and the best beloved is the arbutus."*

when he was invited to return to his old teaching job, he left Roxbury gladly.

While boarding with a prosperous farmer during his second try at teaching, Burroughs found himself attracted to the farmer's daughter. Ursula North was intelligent, high-spirited, and proud. In his notebook that autumn, Burroughs practiced writing the letter "U" and the words "Miss Ursula North" again and again. He also developed a long list of books he intended to read, recorded favorite quotes from other books, and jotted down the titles of essays he hoped to write, among them "The Philosophy of the Porch."

After his contract expired, Burroughs again returned to Roxbury. He boiled maple sap into sugar, corresponded faithfully with Ursula, and made arrangements to resume his formal education. In April he would attend the Cooperstown Seminary, a private school in the next county.

At Cooperstown, Burroughs studied a wide range of subjects, rowed on Lake Otsego, played a new game called "baseball," and let his hair grow long. He also launched his career as a writer. On May 13, 1856, a Catskill newspaper, *The Bloomville Mirror*, printed his first published writing, "Vagaries viz. Spiritualism," under the pen name "Philomath." At the close of the term, Burroughs stood before his classmates and spoke on the subject that was to become his greatest passion—natural history.

Autumn found Burroughs not among the golden maples and coppery beeches of his native hills, but on the prairie, teaching in a schoolhouse at Buffalo Grove, Illinois. He had borrowed fifty dollars from his brother Curtis and used it to follow several of his Ashland academy friends westward. One of these acquaintances was a young woman whom Burroughs much admired.

Burroughs spent six or seven months in Illinois. During that time, his interest in the girl from Ashland

waned while his devotion to Ursula North, the woman he had left behind, grew strong. Soon he decided that neither his salary (forty dollars a month) nor his frequent sightings of prairie chickens were worth the heartache of separation.

Burroughs started home for the Catskills in the spring of 1857. In Chicago, he stopped to pose for a daguerreotype. The photograph is his earliest surviving portrait. It shows a clean-shaven young man of twenty sporting a stylish mane of hair.

When Burroughs returned home, Ursula demanded that he cut his hair. Deeply in love, he acquiesced. Soon he was working once more on his father's farm, helping with the summer haying.

Despite this temporary setback, Burroughs was more eager than ever to make dramatic changes in his life. The summer that began in the fields of his boyhood ended in two bold moves: in July he took a teaching job at High Falls, and on September 12, he married Ursula North.

The pages of Burroughs's notebook reveal an extraordinary single-mindedness. He lists books he plans to read, but the aspiring writer makes no mention of his bride or wedding. For September 12, 1857, the notebook entry consists of merely a list of expenditures—eighteen dollars for a coat, pants, and vest, one dollar for kid gloves, four dollars for a horse and carriage, three dollars to pay a minister, and several other items. Altogether, holy matrimony cost Burroughs thirty-one dollars.

After their wedding, unable to afford living quarters of their own, John and Ursula lived apart. He stayed at High Falls, and she remained with her family. Fridays, Burroughs would dismiss his students early, put on his sturdiest walking shoes, and set off to visit his wife sixteen miles away. He would arrive late Friday night, spend the weekend, and begin the trek back to

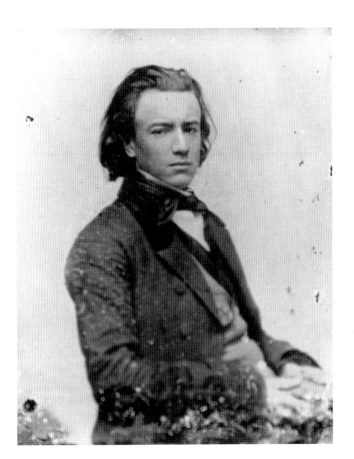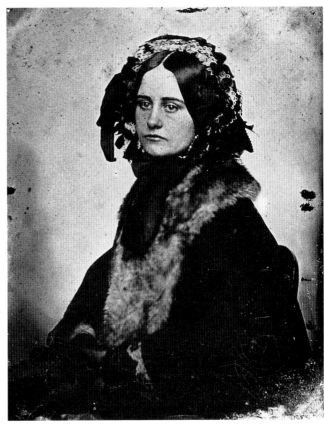

At twenty, Burroughs wore long hair but did not yet sport his trademark beard. On September 12, 1857, a few months after this picture was taken in Chicago, he married Ursula North, a farmer's daughter.

High Falls on Monday morning at 3 A.M. Walking at a brisk pace, he would arrive in time to open the schoolhouse at nine.

In early 1858, late in the winter, John and Ursula began renting a room together in High Falls. About this time, Mrs. Burroughs makes her first appearance in her husband's notebook. The entry is cryptic: "Gave wife 1.00." It is soon followed by "Swindled out of $10, by my own ignorance, in N.Y."

Burroughs's teaching contract at High Falls was not extended, and he and Ursula were forced again to live separately. In the summer, he taught at Rosendale. In the autumn he tried to give up teaching altogether.

Ursula envisioned her husband as a prosperous businessman. At her urging, in the fall of 1858, the twenty-one-year-old ex-schoolmaster tried his hand at manufacturing. He invested in a new type of harness buckle that had been developed by a Hudson Valley inventor. In Newark, New Jersey, Burroughs visited factories seeking one willing to manufacture his buckle. He could stir. up no interest and before long, lacking heart in the enterprise from the beginning, he cut his losses and abandoned the world of business for good.

By mid-February, when the red-winged blackbirds return to their breeding grounds from the south, John and Ursula were living together in a three-room apartment in East Orange, New Jersey. Once again, John found a job as a schoolteacher.

Although he was earning his living in a classroom, Burroughs had no more intention of remaining a teacher than he had of spending his days cutting hay and selling butter like his father. During evenings and weekends he wrote in his notebook, developing essays on philosophical subjects and experimenting with simile and metaphor. "The East began to grow soft and tender," one entry reads, "melting into smiles and blushes at the approach of the sun like a bride when the bridegroom cometh." Another reveals some of the stubborn optimism that provided Burroughs with an invaluable resource in later years: "Adversity does for the man what the rock and the precipice does for the brook; throws him open, makes audible, breaks his silence and reserve, and gives a new impetus to his being." At this time Burroughs began contributing to *The Saturday Press,* a literary periodical. His pieces were published under the pseudonym "All Souls" and titled "Fragments from the Table of an Intellectual Epicure."

The year 1860 brought important events for Burroughs. In the spring, he began a close friendship with E.M. Allen, a young man and fellow intellectual whom he had met the year before. (Allen, three years later, would convince Burroughs to follow him to Washington, D.C.) And in November, the month that Lincoln was elected president, *The Atlantic Monthly* published an essay by Burroughs entitled "Expression."

"Expression" has received little critical attention from Burroughs scholars. Citing the uncanny resemblance of the writing to that of Ralph Waldo Emerson, even admirers of Burroughs have dismissed it as a derivative and insubstantial piece of work. Nevertheless, the essay is remarkable on several counts. Its prose, although heavy-handed at times, is strong and polished. It is rich in the wisdom one might expect only from an older writer. At twenty-three, Burroughs had not yet become a facile writer, but clearly he had already found the key to literary excellence. "As men grow earnest and impassioned," he wrote, "and speak from their inmost heart, and without any secondary ends, their language rises to the dignity of poetry." Elsewhere in the piece, Burroughs opined that "the language of the actual and the practical applied to the ideal brings it at once within everybody's reach, tames it, and familiarizes it to the mind." This thought—revolutionary in an era of overwrought prose—is followed

by a sort of credo that, in years ahead, would give Burroughs's own writings great popularity with the masses. "If writers . . . would deal more in our everyday speech, use commoner illustrations, seek to find some interpreter of the feelings and affections of the mind in Nature, out of the mind itself . . . they would be far more fruitful and satisfying."

During the next three years, until the autumn of 1863, John Burroughs alternated between temporary schoolteaching posts (at Newark, and later in New York at Marlboro, Olive, and Buttermilk Falls) and short stints on the family farm. At one point, in low spirits and desperate for a change, he tried studying medicine under his old friend, Dr. Hull. He was unhappy from the start, and his days as a medical student were few.

Burroughs's best ally during hard times was his own optimism—a fatalistic, but doggedly positive optimism that never failed him. While studying medicine, he set down his philosophy in verse, and the poem that resulted, "Waiting," became one of his most popular works. It begins:

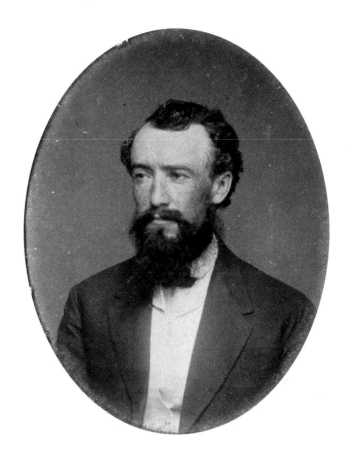

At age twenty-five, Burroughs was busily occupied teaching school, writing a column called "From the Back Country" for the New York Leader, *and beginning to correspond with the poet Myron Benton, who became a lifelong friend.*

> *Serene, I fold my hands and wait,*
> *Nor care for wind, nor tide, nor sea;*
> *I rave no more 'gainst Time or Fate,*
> *For lo! my own shall come to me.*
>
> *I stay my haste, I make delays,*
> *For what avails this eager pace?*
> *I stand amid the eternal ways,*
> *And what is mine shall know my face.*
>
> *Asleep, awake, by night or day,*
> *The friends I seek are seeking me;*
> *No wind can drive my bark astray,*
> *Nor change the tide of destiny.*

Although Henry Thoreau and Burroughs never met, the naturalist admired Thoreau and his writings. Walden, *said Burroughs, "is the best book of the kind in English literature."*

It was probably easier for Burroughs to write "Waiting" than to live by its philosophy, but by struggling to do so, he gained the strength he needed to continue seeking a vocation that he could enjoy.

When he wasn't instructing pupils or pitching hay, Burroughs was contributing newspaper columns (in 1861 he began writing pieces on farm life under the title "From the Back Country") to the *New York Leader*, recording ideas in his notebook, and keeping up with correspondence. His two most faithful pen pals were E.M. Allen, who had moved from New Jersey to Washington, D.C., and Myron Benton, a young farmer from Dutchess County, New York. An avid reader of "From the Back Country," Benton had written Burroughs a letter of appreciation in August, 1862.

The most notable action that Burroughs *did not* take during this critical phase of his development was enlisting in the Union Army. Although he admired Lincoln, supported his cause, and wrote on July 10, 1862, to Ursula, "It is time every man took a musket . . . ," he chose to avoid the line of fire. This was a decision that, in later life, Burroughs often lamented, even though becoming a soldier would have cut straight across his pacifistic grain. Throughout his long life, Burroughs was often a conciliator, rarely a warrior.

In 1863, while teaching at Buttermilk Falls, the twenty-six-year-old Burroughs took up the study of plants. He had been encouraged to do so by a friend, a professor of botany, who regularly took him on field trips. Burroughs soon found himself scouring the woods for wildflowers. At about the same time, partly by coincidence, Burroughs rediscovered his interest in birds. He had found John James Audubon's books in the library at the U.S. Military Academy at West Point, and had been captivated by their sprawling, hand-colored illustrations and the descriptions of many birds he had seen. The two interests—plants and birds—

In Washington, Burroughs met the poet Walt Whitman. Quickly the two became friends. Burroughs wrote one of the first critical studies of Whitman and, after the poet's death, produced a second volume celebrating his life and his masterpiece, Leaves of Grass. "There are born to a race or people," wrote Burroughs, "men who are like an irruption of life from another world, who belong to another order, who bring other standards. . . . It is here, in my opinion, that we must place Whitman; not among the minstrels and edifiers of his age, but among its prophets and saviors."

Ralph Waldo Emerson was John Burroughs's first great literary hero. In his journal, Burroughs wrote, "Emerson was my spiritual father in the strictest sense. It seems as if I owe nearly all, or whatever I am, to him. I caught the contagion of writing and of authorship before I knew his books, but I fell in with him just in time. His words were like sunlight to my pale and tender genius."

Burroughs advocated the use of the name "trout lily" for a wildflower better known as "dogtooth violet" or "adder's tongue." The plant is not a violet but rather a true lily, and it blossoms in early spring when trout fishermen are returning to woodland streams. The name caught on, and Erythronium americanum *is best known today by the name Burroughs promoted.*

complemented each other and together helped inspire an August camping expedition to the Adirondacks in the company of his friends Myron Benton, E.M. Allen, and a man he called simply "Jaspar." During the trip, delighted by the scenery and pleased by his own familiarity with the plants and animals he saw, Burroughs first began to think of himself as a naturalist.

The most significant events of 1863 for Burroughs were meetings with the two men who were his greatest heroes: Ralph Waldo Emerson and Walt Whitman. In May or June, Burroughs first met with Emerson. The New England philosopher and poet had come to West Point to give a lecture. Afterward, Emerson walked with the young Catskill schoolmaster on the Academy grounds and spoke with him cordially.

In October, fed up with teaching, Burroughs sent Ursula to board with her parents and set off for Washington, D.C., in search of a new job. The nation's capital was busily engaged in fighting the Civil War. Burroughs soon found—and lost—a position with the Quartermaster General managing supplies and burying African-American soldiers. Burroughs's disappointment at being fired was soon offset by the thrill of a great event. One day, Walt Whitman, the controversial, iconoclastic poet whose works Burroughs deeply admired, walked into a store run by E.M. Allen, and Burroughs shook his hand.

Whitman's *Leaves of Grass* was already in its third edition. Ralph Waldo Emerson had declared the book to be America's greatest literary masterpiece, but most critics of the era felt otherwise. They considered Whitman's rambling, avant-garde poems coarse and lurid and complained that they lacked conventional prosody such as rhyme and meter. In 1863, few literary-minded folk considered Whitman a genius. John Burroughs was one of them. After their first brief meeting, Burroughs encountered Whitman frequently

at Allen's store, and the two became friends.

On January 7, 1864, Burroughs arrived for an interview at the office of Hugh McCulloch, Comptroller of Currency under Secretary of the Treasury Salmon P. Chase. McCulloch later recalled: "One day a young man called at my office and said to me that he understood that the force of the bureau was to be increased, 2nd [*sic*] that he should be glad to be employed. I asked him if he had any recommendations. 'I have not,' he replied, 'I must be my own.' I looked at his sturdy form and intelligent face, which impressed me so favorably that I sent his name to the Secretary, and the next day he was at work as a twelve hundred dollar clerk." Burroughs performed well in the job and continued to work for the Treasury Department, in varying capacities, until 1885.

Now that Burroughs had secured a steady job, his wife rejoined him. Together they rented a comfortable two-story brick house which stood where the Senate Office Building rises today. To economize, they sublet upstairs rooms to tenants. The house came with an acre of land where the Burroughses grew most of their own produce, kept chickens, and tethered a milk cow that grazed freely by day on the Capitol commons. By selling milk and eggs, raising most of their own food, and renting rooms, the young couple managed to set aside half of Burroughs's salary.

Despite skirmishes between Union and Confederate soldiers that sometimes came so close to Washington that residents could hear the gunfire, the days passed peacefully for Burroughs. He rose early every morning, worked in the garden, and then put on clean clothes and walked the mile to the Treasury. There, after reporting for work at 8:30 A.M., he sat at a desk outside the door of a great iron vault. "Uncle Sam was a very easy master," Burroughs later recalled. "He paid us well and didn't insist on our working very hard."

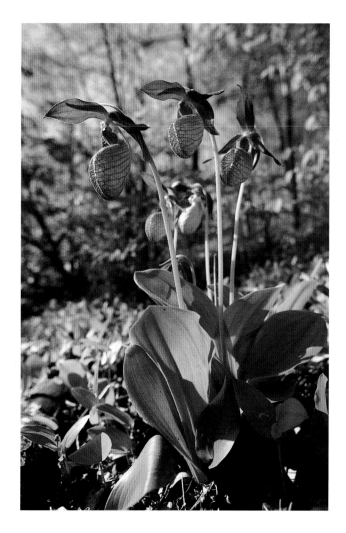

Pink ladyslipper orchids.

To help pass the time, Burroughs wrote nature essays. He had been encouraged to do so by Whitman, and wrote in a plain unaffected style that came easily to him. Burroughs penned essays with titles such as "With the Birds," "The Snow Walkers," and "In the Hemlocks." These and others were published regularly over the next few years in *The Atlantic Monthly.* At four each afternoon, after seven hours spent watching the vault and writing, Burroughs walked home.

On Sundays, and during other scattered hours of leisure, Burroughs tramped with friends in Rock Creek Park and other nearby woods, sat discussing life and literature on the Capitol steps with Walt Whitman (while Chloe, Burroughs's Devonshire cow, grazed nearby on the Capitol commons), and tended his garden. One day, driven by curiosity, Burroughs walked several miles to the battlefront to get a first-hand look at the Civil War. He returned shaken. The blood and the corpses appalled him, and bullets had whistled uncomfortably close to his head.

From a Treasury window, Burroughs occasionally glimpsed Abraham Lincoln, who was fond of taking shortcuts on foot down back streets and alleyways. Though Burroughs admired Lincoln, he was not among those gathered at the Capitol when the President took his second oath of office on March 4, 1865. Burroughs's notebook records: "Today . . . made my first excursion to the woods. Everett and I thought it more desireable to see Spring inaugurated than Pres. Lincoln, as significant and gratifying an event as the latter is. The afternoon was deliciously clear and warm—real vernal sunshine, though the wind roared like a lion over the woods." Burroughs returned home pleased that he had found the wildflowers hepatica and bloodroot emerging from the ground, and that he had heard a bluebird singing "like the first tremulous voice of spring."

Working at his desk in the Treasury building, Burroughs continued to pen essays for *The Atlantic Monthly.* Whenever he had the chance, he discussed his ideas in advance with Walt Whitman, and the poet, then in his forties, began to exert a strong influence on him. Whitman encouraged Burroughs to write about the things Burroughs knew and loved best—country life and the out-of-doors. Burroughs listened. He wrote one nature piece after another—the bulk of which were later to appear in his second book—and slowly the cold rhetoric of his earliest essays began to yield to a style that was warm and sensuous. Burroughs's emerging style clearly owed much to Whitman.

For example, in an *Atlantic* essay titled "With the Birds" (1865), Burroughs wrote of the "wooing" of songbirds, the "long, tender note of the meadowlark," and "the emotions excited by the songs of . . . thrushes" arising "from our deepest sense of the beauty and harmony of the world." The writing is full of emotion, much like Whitman's. Burroughs described the birds with a scientist's accuracy, but he avoided technical jargon and told readers how the birds made him feel.

During the same period, Whitman, whose poems were under frequent attack by critics, encouraged the impressionable Burroughs to write a book celebrating *Leaves of Grass.* The work began to take shape in 1866. How much of it was written by Burroughs, and how much by Whitman himself, has never been precisely determined. (As an old man, Burroughs acknowledged—without reference to specific passages—that his subject had made direct contributions.) The American News Company in New York published *Notes on Walt Whitman as Poet and Person* in 1867. It was John Burroughs's first book, and only the second lengthy critical assessment to be written about Whitman. Burroughs paid most of the publishing costs himself.

As Whitman's critic, Burroughs made his bias clear

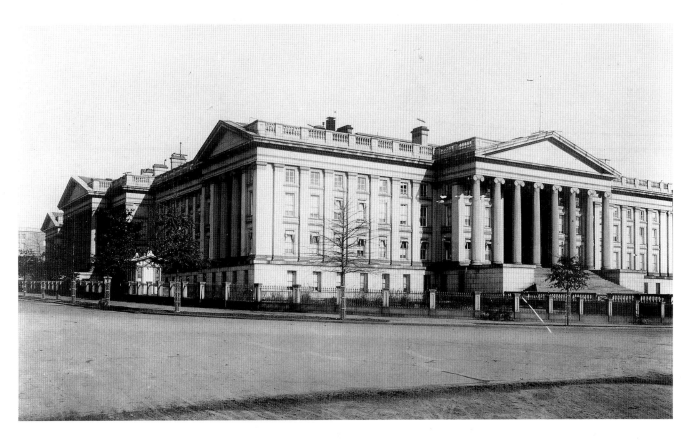

At the United States Treasury building in Washington, D.C.,
John Burroughs began work as a clerk on January 8, 1864.
Here, sitting at a desk beside an open vault, he wrote his first
polished nature essays.

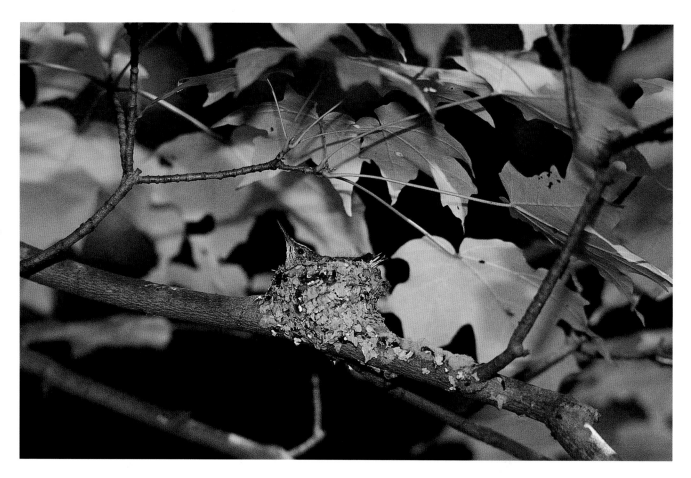

"The woods hold not such another gem," wrote John Burroughs, "as the nest of the hummingbird."

RIGHT: *During the lifetime of John Burroughs, the tufted titmouse, a close cousin of the black-capped chickadee, visited the Catskills only occasionally. Burroughs saw the bird often, however, during the years he lived in Washington, and later, during his frequent travels in the South. Today the bird nests throughout the Catskills.*

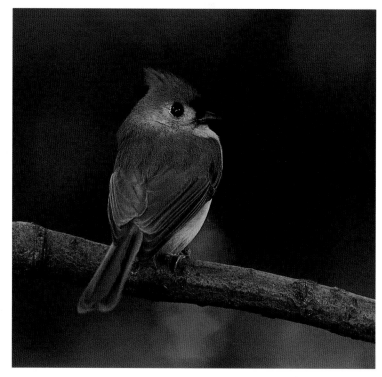

in the preface. "I consider that America is illustrated in [Whitman]; and that Democracy as now launched forth upon its many-vortexed experiment for good or for evil . . . is embodied, and for the first time in Poetry grandly and fully uttered, in him."

The book did little to advance Whitman's reputation or diminish his notoriety. Most of the copies, Burroughs recalled in later years, sat in his parlor unsold. Today, the work is chiefly a curiosity—an early critical work (however prejudiced in its subject's favor) on Whitman and the first book to spring from the inkwell of Burroughs.

Burroughs was well aware of the book's defects. He wrote to Myron Benton, who was planning to review *Notes on Walt Whitman,* and advised his friend "not to spare me." In the preface, Burroughs described the chapters that followed as "crude and ill-put," although he hoped, he told readers, that "they too may serve." The book attracted little notice. For the disappointed author, now thirty, it was back to the Treasury for more desk work and nature writing.

Through the late 1860s, Burroughs's friendship with Whitman flourished, and when the poet needed help with botany or zoology, he often turned to Burroughs for advice. The most striking example of a contribution by Burroughs to a Whitman poem can be found in "When Lilacs Last in the Dooryard Bloom'd." A hermit thrush sings repeatedly through "Lilacs," its plaintive notes helping to underscore the poem's melancholic atmosphere. Burroughs suggested the bird and its song to the poet after Whitman had asked his advice. The hermit thrush nests on mountains and in northern forests; Burroughs knew the bird from his Catskill boyhood; Whitman, a native Long Islander, did not.

John Burroughs was devoted to writing, friends, and leisure-time adventures afield. He was not an ideal

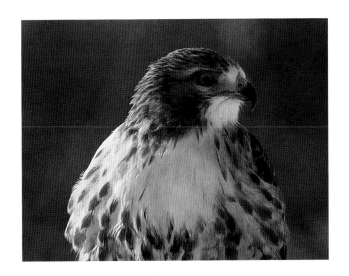

In Wake-Robin, *Burroughs described the red-tailed hawk as "beautiful," "majestic," and "always at his ease." This was an unusual outlook upon a bird which—at the time—was almost universally condemned for its predatory feeding habits.*

NEXT PAGES: *"In the Hemlocks" (* Wake-Robin) *celebrates the beauty and diversity of forests such as this one near Keene Valley in the Adirondacks.*

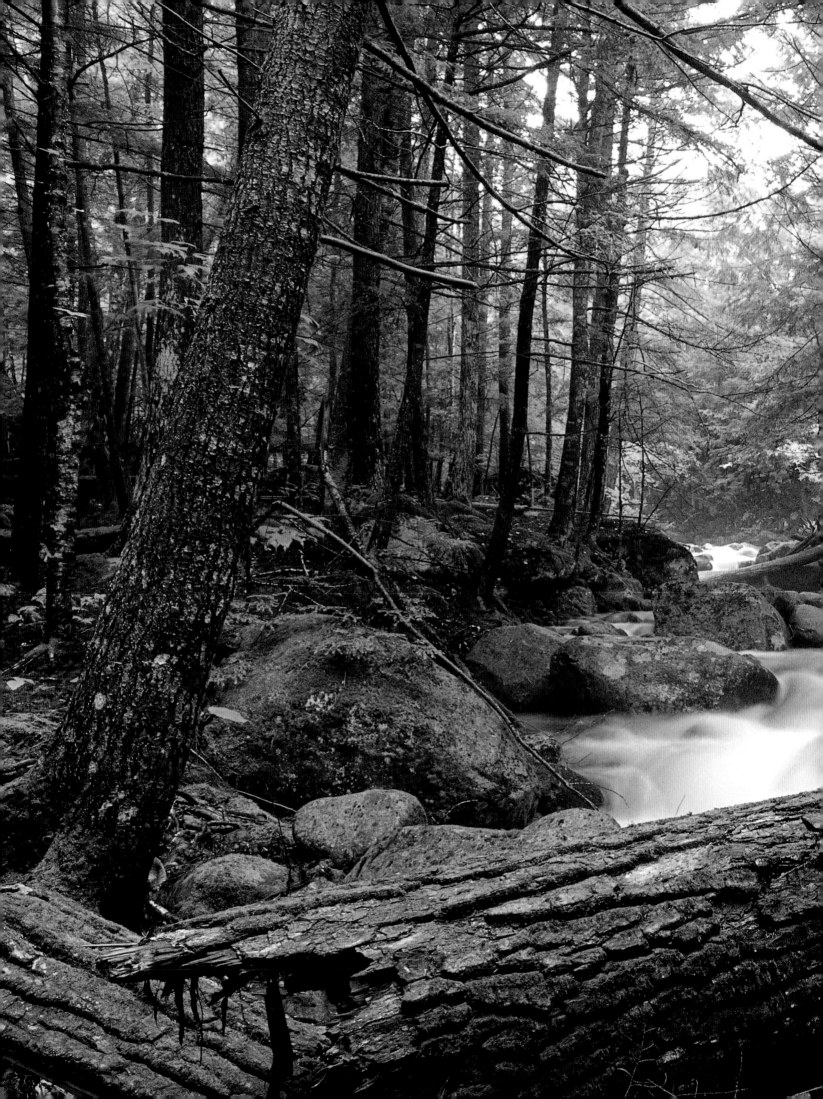

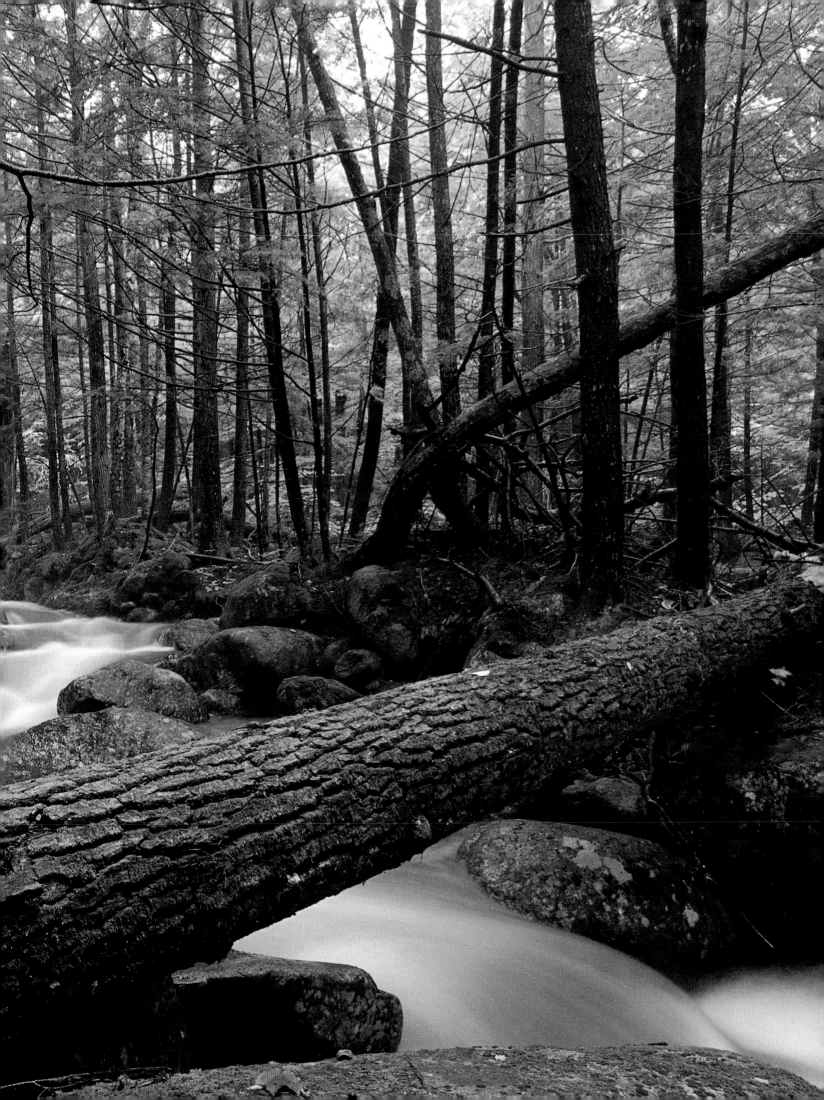

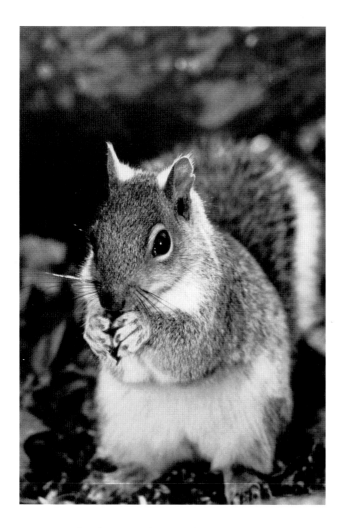

Gray squirrel. *"There is something very human,"* wrote
Burroughs *in his second nature book, in the "*. . . *mirth
and mockery of the squirrels. It seems to be a sort of ironi-
cal laughter, and implies self-conscious pride and exulta-
tion in the laughter. 'What a ridiculous thing you are, to
be sure!' he seems to say; 'how clumsy and awkward, and
what a poor show for a tail! Look at me, look at me!'—
and he capers about in his best style."*

husband for a woman of conventional sensibilities, and
so strong were his outside interests that he was
undoubtedly a difficult man with whom to share any
sort of domesticity. As for Ursula, she was a house-
keeper of iron discipline and rigid tastes. She contin-
ued to chastise John for "scribbling" and socializing
when he could have been earning money or attending
to household chores. Their efforts to begin a family
were complicated by Ursula's health, which was often
poor, and by frequent squabbles. Years passed, the ran-
cor persisted, and the couple remained childless.

In 1871, the Boston publishers Hurd and Hough-
ton (later to become Houghton Mifflin) brought out
Burroughs's second book, *Wake-Robin.* The volume was
a collection of nature pieces, mostly about birds.
Several of the chapters had appeared in slightly differ-
ent form in *The Atlantic Monthly.* Walt Whitman had
picked the title after Burroughs had shown him a list
of prospects.

Unlike its predecessor, *Wake-Robin* sold well for a
book by a little-known author, and it was widely
praised by critics. The novelist William Dean Howells,
reviewing the book in *The Atlantic* (of which Howells
was editor), observed that Burroughs had "succeeded
so well . . . that the dusk and cool of the forest seem
to wrap the reader . . . and it is a sort of summer
vacation to turn its pages." Howells also cited the
author's sense of humor, and summed up the work as
"fresh, wholesome, sweet, and full of a gentle and
thoughtful spirit." *The New York Evening Post* reviewed
Wake-Robin with similar enthusiasm, predicting that
it would "take rank with [Gilbert] White's *Selborne*
and other volumes of natural history that are regarded
as classic."

Between its covers, *Wake-Robin* contained chapters
with titles such as "In the Hemlocks," "The Adiron-
dacks," "Spring at the Capitol," and "Birch Brows-

ings." The writing was vigorous and personal, as in this passage from "In the Hemlocks":

Ever since I entered the woods, even while listening to the lesser songsters, or contemplating the silent forms about me, a strain has reached my ears from out of the depths of the forest that to me is the finest sound in nature,—the song of the hermit thrush. I often hear him thus a long way off, sometimes over a quarter of a mile away, when only the stronger and more perfect parts of his music reach me; and through the general chorus of wrens and warblers I detect this sound rising pure and serene, as if a spirit from some remote height were slowly chanting a divine accompaniment. This song appeals to the sentiment of the beautiful in me, and suggests a serene religious beatitude as no other sound in nature does. It is perhaps more of an evening song than a morning hymn, though I hear it at all hours of the day. It is very simple, and I can hardly tell the secret of its charm. "O spheral, spheral!" he seems to say: "O holy, holy! O clear away, clear away! O clear up, clear up!" interspersed with the finest trills and the most delicate preludes. It is not a proud gorgeous strain, like the tanager's or the grosbeak's; suggests no passion or emotion,—nothing personal,—but seems to be the voice of that calm, sweet solemnity one attains to in his best moments. It realizes a peace and a deep, solemn joy that only the finest souls may know. A few nights ago I ascended a mountain to see the world by moonlight, and when near the summit the hermit commenced his evening hymn a few rods from me. Listening to this strain on the lone mountain, with the full moon just rounded from the horizon, the pomp of your cities and the pride of your civilization seemed trivial and cheap.

Passages such as this, and others like it throughout *Wake-Robin*, provide fine examples of the kind of writing that would make Burroughs an acknowledged master of the nature essay. The recipe was simple: begin with field observations, stir in heartfelt emotions and sensibilities, and spice liberally with anecdotes.

In October, pleased with the success of *Wake-Robin*, Burroughs sailed to England on official business for the United States Treasury. There he met another of his heroes, the historian and author Thomas Carlyle, and ventured briefly across the Channel to Paris. Aside from the reactions of his tender stomach to the North Atlantic, Burroughs enjoyed the adventure greatly.

On December 31, 1872, after a quiet year of writing, reading, and work at the Treasury, Burroughs resigned his post. He had had his fill of city life. A temporary job had opened up as the receiver of a failed bank in Middletown, New York, a few miles from his native hills. Burroughs accepted it eagerly.

Essayist and Grape Grower

On New Year's Day, 1873, Burroughs became a bank examiner. He was thirty-five years old, the author of two books, and alone. Ursula had remained behind in Washington while he began the search for a new home.

First on Long Island, and later along the shores of the Hudson River, Burroughs scrutinized farms and farmhouses. He aimed, if it was possible, to find a place that would lie within a day's journey of both New York City, where important figures in the publishing business were located, and the Catskills, where his parents still worked the family farm. At last he found and purchased a site that seemed ideal—the "Deyo place," a small vineyard on the west bank of the Hudson, near Poughkeepsie.

Burroughs designed a new house for the property, and during the late summer, autumn, and winter he worked with carpenters and masons to build it. The structural timbers and siding were cut in nearby woods. The paneling and moldings—of native hardwoods such as butternut, maple, cherry, and ash—were milled from trees cut in Chauncey Burroughs's Roxbury woodlots. Fieldstones for the walls were collected and cut on the site. Through the months of construction, John and Ursula lived nearby in an old wooden house.

In the autumn of 1874, the following year, the new house was ready. John later dubbed it "Riverby," meaning "by the river." It was a big place, perhaps a bit *too* roomy for a couple with no children. It proved damp in summer and drafty in winter. Despite these drawbacks, Riverby served as the home of John and Ursula for the rest of their lives.

Bank-receiving did not provide Burroughs with full-time, year-round work. Between jobs there were idle weeks, and these he spent working in the Riverby vineyard, exploring the countryside, and writing essays. A selection of the pieces he wrote at this time was collected in his third book, *Winter Sunshine*, published in 1875. The volume included a series of essays based on his trip to England, while other chapters featured subjects closer to home, such as "The Fox," "The Snow-

OPPOSITE: Near Riverby, Black Creek flows through a series of waterfalls before emptying into the Hudson. Burroughs called the deep woods surrounding the falls "Whitman Land" after walking there with the poet Walt Whitman. In summer, Burroughs often retreated here to relax, read, and contemplate.

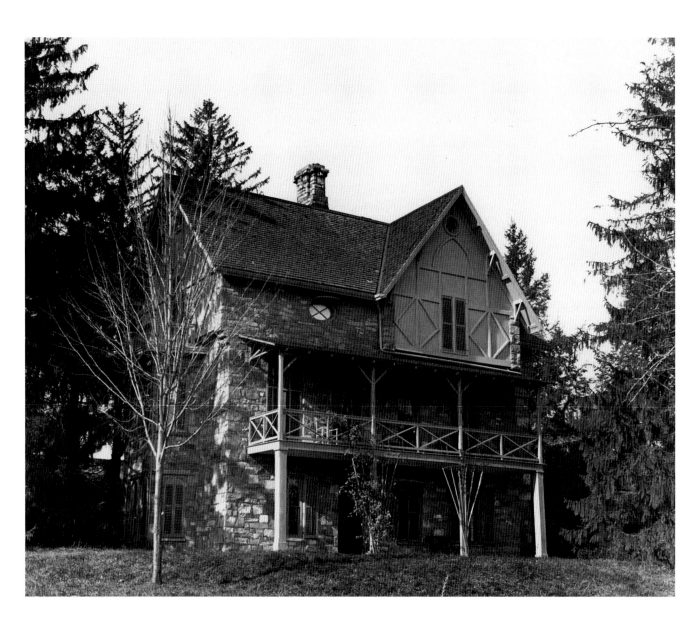

Near Poughkeepsie, New York, on the western shore of the Hudson River, stands the stone house that Burroughs called Riverby.

Walkers" (about animal tracks in snow), and "The Apple."

The opening paragraphs of "The Snow-Walkers" are characteristic of the style Burroughs employed throughout *Winter Sunshine*—a manner of writing that managed to be intellectual, down-to-earth, evocative, and intensely personal all at the same time:

He who marvels at the beauty of the world in summer will find equal cause for wonder and admiration in winter. It is true the pomp and the pageantry are swept away, but the essential elements remain,—the day and the night, the mountain and the valley, the elemental play and succession and the perpetual presence of the infinite sky. In winter the stars seem to have rekindled their fires, the moon achieves a fuller triumph, and the heavens wear a look of more exalted simplicity. Summer is more wooing and seductive, more versatile and human, appeals to the affections and the sentiments, and fosters inquiry and the art impulse. Winter is of a more heroic cast, and addresses the intellect. The severe studies and disciplines come easier in winter. One imposes larger tasks upon himself, and is less tolerant of his own weaknesses.

The tendinous part of the mind, so to speak, is more developed in winter; the fleshy, in summer. I should say winter had given the bone and the sinew to Literature, summer the tissues and blood.

"His sketches have a delightful oddity, vivacity, and freshness," wrote Henry James, reviewing *Winter Sunshine* for the magazine *The Nation*. James credited Burroughs with "a real genius for the observation of natural things," and summed him up as "a sort of reduced but also more humorous, more available, and more sociable Thoreau."

James had hit the mark exactly. Unlike Thoreau, Burroughs was no misanthrope. Burroughs's essays were inviting and easy to read; they lacked the sharp cutting edge of Thoreau's book *Walden* and his essay "Civil Disobedience." Reading Burroughs was like spending time in the woods and fields with a companionable friend. In his writings as in person, Burroughs was erudite but easygoing, unpretentious, and never condescending.

As booksellers distributed *Winter Sunshine* to the author's widening circle of readers, the thirty-eight-year-old Burroughs was already at work on a new volume of essays, which would include several in the genre of literary criticism—the first of dozens of such essays Burroughs would eventually write. Progress on the project was uneven, and John wrote his friend Myron Benton at year's end: "I write quite easily this winter, often an article a week, and often, I fear, a weak article."

In May, as the wildflowers at Riverby were blossoming and the songbirds were returning from the South, Burroughs abandoned the notebooks in which he had recorded miscellaneous thoughts, debts, and grocery lists since 1854. Now he began to keep a formal journal. In inexpensive notebooks filled with ruled paper, he would make entries almost daily until his death in 1921.

The journal begins: "May 13. Standing in the road over in the woods I saw a lively little shadow, cast by some object above and behind me, on the ground in front of me. Turning I saw the source of it—the redstart performing its astonishing gymnastics in a leafless oak tree. . . . It is the quickest and prettiest of the fly-

NEXT PAGES: Burroughs's landholdings at Riverby sloped down to meet the Hudson River at this slate beach. "The river idealizes the landscape," wrote Burroughs of the Hudson. "It multiplies and heightens the beauty of the day and season. A fair day it makes more fair, and a wild tempestuous day it makes more wild."

catchers. . . ." Behavioral observations of the bird filled the next two pages.

Burroughs's journal soon teemed with similar discoveries. He studied every bird, flower, and insect with unfailing enthusiasm, and sometimes his passion led to actions he would later regret. In the autumn of 1876, for example, he spotted his last wild passenger pigeon, shot it, and ate it for supper.

In January, 1877, *Scribner's* printed an essay assessing Burroughs's literary accomplishments to date. The criticism may not have been entirely objective—its author was Joel Benton, the brother of Burroughs's friend Myron Benton—but it received a wide readership and announced in clear terms that Burroughs was an important new writer. "Mr. Burroughs's style," Joel Benton wrote, "is racy, full of blood, vascular, and bristling with just the words for the description in hand. It is idiomatic, original, but individual still more; and has been melted out by the strong heat of thought."

Burroughs's next book, *Birds and Poets* (1877), met and perhaps exceeded Joel Benton's expectations. It was a thoughtful, stimulating potpourri of thoughts and ideas on subjects ranging from Shakespeare, Wordsworth, Emerson, and Whitman, to the passenger pigeon, the paper-making hornet, and the milk cow. The cow, in fact, stood on an equal footing in the book with Emerson and Whitman, meriting an essay all its own. "Our Rural Divinity," the most overtly humorous Burroughs piece that had appeared thus far, celebrated all cows, but particularly Chloe, the Devonshire "milcher" that the author had kept, milked, and adored in Washington.

I have owned but three cows and loved but one. That was the first one, Chloe, a bright red, curly-pated, golden-skinned Devonshire cow, that an ocean steamer landed for

me upon the banks of the Potomac one bright May Day many clover summers ago. She came from the North, from the pastoral regions of the Catskills to graze upon the broad commons of the national capital. . . .

How she liked the voyage I could not find out; but she seemed to relish so much the feeling of solid ground beneath her feet once more, that she led me a lively step all the way home. She cut capers in front of the White House, and tried twice to wind me up in the rope as we passed the Treasury. . . .

Burroughs kept Chloe for two summers. Then, in what he admitted was an "evil moment," he put her up for sale in a public marketplace. The cow was bought by a butcher, and Burroughs was left to lament his betrayal.

Visitors began to find their way to Riverby, including a long succession of fellow authors and admirers. Among the first was Edward Carpenter, an English writer and a friend of Walt Whitman. Years later, Carpenter recalled the 1877 visit in his autobiography. He found John Burroughs a man with "a tough reserved farmer-like exterior, some old root out of the woods one might say . . . but a keen, quick observer close to Nature and the human heart, and worth a good many [Oliver Wendell] Holmes and [James Russell] Lowells."

Walt Whitman also came, bringing along a male companion named Harry Stafford. Burroughs seems to have been unaware of, or at least unwilling to acknowledge, Walt's sexual preferences (although he once wrote that his friend "kissed me like a girl"), but he was troubled nonetheless by the poet's behavior. "They cut up like two boys and annoyed me sometimes," Burroughs wrote of Whitman and Stafford. ". . . Can't get them up to breakfast in time."

Whitman returned for a second visit to Riverby the following year, which he recalled in *Specimen Days*, describing "the handsome, roomy, honeysuckle-and-rose-embower'd cottage of John Burroughs" and "the perfect June days and nights . . . the hospitality of J. and Mrs. B., the air, the fruit (especially my favorite dish, currants and raspberries . . .)—the room I occupy at night, the perfect bed, the window giving an ample view of the Hudson. . . ."

During the preceding year, Burroughs had often lived alone, keeping house while his wife visited hospitals and spas seeking a cure for infertility. These were difficult times. In a journal entry dated March 25, 1878, Burroughs reported that, despite the success of his writings, "I am not happy." A few weeks later he returned from a bank-examining trip to Elmira, complaining of "a fearful neuralgia in my arm and shoulder" and "the severest pain of my life."

Burroughs hailed the cow as "Our Rural Divinity," writing, "[the cow] has not the classic beauty of the horse, but in picture-making qualities she is far ahead of him. Her shaggy, loose-jointed body; her irregular, sketchy outlines, like those of the landscape . . . all tend to make her an object upon which the artist eye loves to dwell."

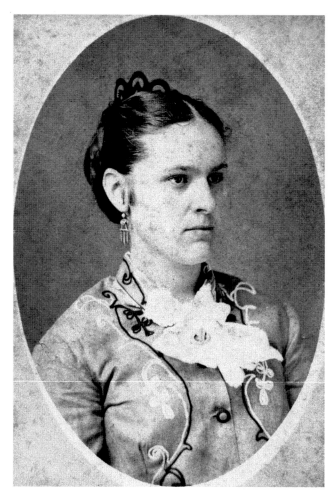

Of the great events of John Burroughs's life, none brought him more joy than the arrival in 1878 of a son, Julian, his only child.

Amanda Henion, a housemaid at Riverby and friend of Burroughs's niece, Emma Caswell.

But the days brightened. In May, fishing in Meeker's Hollow at Roxbury, Burroughs "caught 10 lbs. of beautiful trout—103 [fish] in all," and in June, Whitman came to visit at Riverby. The most dramatic event of the year, however, appears in the journal with little forewarning. On the first day of July, Burroughs wrote: "Baby came to-day—a great event." The baby was a boy, and John and Ursula named him Julian.

Among the biographies of Burroughs already in print, most have treated the arrival of Julian cryptically. Ursula is never mentioned in connection with a pregnancy, even though such a condition would have been cause for wild rejoicing in a household that for more than two decades had tried fruitlessly to produce a child. Nor is the event of Julian's birth described; one moment he is nonexistent, the next he has arrived. One recent biographer, however, suggests a very different scenario: that Burroughs fathered the boy by an Irish housemaid, plucked him from his mother's arms early on the morning of his birth, and carried him home unrepentantly to his wife. This story, provided without supporting documentation, concludes with a sinister twist. Burroughs, presumably to safeguard his good name, makes sure that the housemaid is safely out of the way by shipping her back to Ireland.

The truth of the matter might have come to light much sooner. Burroughs did not suppress the facts. To the contrary, he supplied them with accompanying papers to his authorized biographer, Clara Barrus. But after Burroughs's death, his friend Judge A.T. Clearwater persuaded Barrus to remove from her *Life and Letters of John Burroughs* a chapter that told the real story. (This chapter, along with Julian's adoption papers and other evidence, later came into the hands of Julian and his eldest daughter, Elizabeth. In a December 1992 interview, Elizabeth, now 89, pointed to her fireplace and said, "I can still see the papers burning

there. It may not have been the right thing to do—I don't know—but I destroyed them to please my mother.")

In July of 1877, Burroughs had sexual relations with Amanda Henion, a German girl from the Catskill village of Rondout. Henion was a friend of Emma Caswell, a niece of Burroughs who lived in a house at Riverby. Since the autumn of 1876, Henion had worked in the Burroughs home as a maid. Whether she and Burroughs carried on an extended affair or enjoyed only a brief moment of passion will likely never be known, but given the watchful eye and fierce temper of Ursula Burroughs, it seems probable that the connection between the two was short-lived. At any rate, Ursula learned of the liaison in early July and a domestic firestorm ensued. Henion was fired, Ursula fled Riverby for Poughkeepsie, and Burroughs set off on an extended camping trip to Canada. He returned home on August 4 to find that Ursula remained "away under peculiar circumstances."

Eventually Ursula was persuaded to return, and a measure of peace returned to Riverby. But a change was in the wind. Several months later, in the spring of 1878, Burroughs received a letter from a Dr. Anna Angell. Angell worked as a physician at a New York City home for foundlings where, on April 15, Amanda Henion had given birth to a baby boy. Henion had confided to her doctor that the child's father was John Burroughs. Burroughs himself knew of the pregnancy, and since first receiving word of it in a letter from Henion, had been quietly paying her lost wages and medical expenses.

Soon a remarkable plan was hatched. Ursula, now in her forties, was told by a doctor that her chances of bearing a child were slimmer than ever, and that it would be in the interests of her health and happiness to adopt an orphan. (Elizabeth Burroughs Kelley

believes that Dr. Angell probably had a hand in seeing that Ursula received such advice.) Burroughs then brought Ursula to New York, to the Quaker home where his two-month-old son was being cared for. Here, with the deft assistance of Dr. Angell, he persuaded Ursula to adopt his own child. Eight years would pass before Ursula learned that her adopted son's father was her own husband.

Amanda Henion, meanwhile, returned to the Catskills, married, and settled in Highland, a village on the Hudson's west bank just a few miles south of Riverby.

The arrival of the baby marked the beginning of happier days at Riverby. Ursula devoted herself to caring for the child as if he were her own, and Burroughs relished his new role as father and mentor. Burroughs wrote Myron Benton in November: "The youngster by the way is doing well. His senses and his intelligence are very keen and I think I see a future poet in him. He and I have great times already."

Despite the demands of an infant in a household that had been long childless, Burroughs continued to enjoy fatherhood. In February he again wrote to Myron Benton, "The baby is a refuge from my barren and unhappy moods much of the time: he grows finally and he & I have quite an understanding already. I take him out riding on the hand sled & he crows & exults like any other boy. You must come see him & his parents."

Although the tenor of John Burroughs's life had changed dramatically, his bank-receiving, work in the vineyard, and writing continued without interruption, and he still found time to roam in the woods and fields. Mostly he kept close to home, but twice he managed to slip away for camping trips. One was made with his Washington friend Aaron Johns to a Catskill stream, the Neversink. The other was a solo journey

afloat, in a boat he had built himself, down the Pepacton River. In 1879, Burroughs's fifth book was published. It was a volume of nature essays entitled *Locusts and Wild Honey.*

Among the outstanding essays in the new collection was "Strawberries," in which Burroughs's descriptive skills, sense of humor, and Whitman-influenced imagery melded seamlessly. After describing how he grew strawberries indoors one winter, Burroughs confessed: "In March the berries were ripe, only four or five to a plant, just enough, all told, to make one consider whether it was not worth while to kill off the rest of the household, so that the berries need not be divided." Burroughs later described picking wild strawberries in June. The words were entirely his own, but the sexually charged tone of the passage owed much to Whitman and *Leaves of Grass:* "Your errand is so private and confidential! You stoop low. You part away the grass and the daisies, and would lay bare the inmost secrets of the meadow. Everything is tender and succulent; the very air is bright and new; the warm breath of the meadow comes up in your face. . . ."

In the autumn of 1879, John Burroughs saw Ralph Waldo Emerson for the last time—at a party in Boston celebrating the birthday of Oliver Wendell Holmes. Burroughs reported the affair in his journal, noting, "Saw and spoke with Emerson. He is the most divine-looking man I ever saw—does not look like a saint, but like a god."

By the end of the 1870s, Burroughs had risen from obscurity to prominence. In the 1880s, his fame and popularity continued to grow. The joys of profes-

Burroughs's parents are buried in an old Baptist cemetery near Stratton Falls, in Roxbury. Burroughs outlived his entire family and visited their graves often.

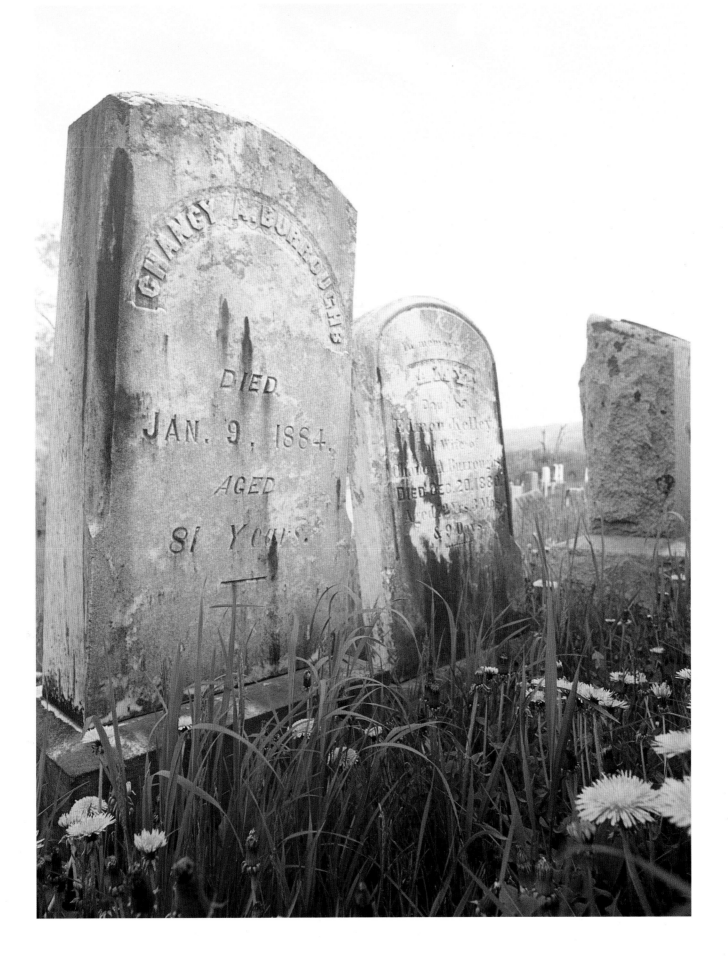

sional success, however, were tempered by a series of personal sorrows. In 1880, a little more than a year after she had suffered a seizure, his mother Amy Kelly Burroughs died at the age of seventy-two. Three years and one month later, his father Chauncey died at eighty-one. Both were buried in the Old Baptist Cemetery near Stratton Falls.

These losses saddened Burroughs greatly. So did the death of Lark, his dog, in 1881. Burroughs formed close bonds with animals, especially dogs, which were often his favorite companions in the field. "One's pleasure with a dog is unmixed," he wrote in his journal the day Lark died. "There are no set-backs. They make no demands upon you as does a child; no care, no interruption, no intrusion. If you are busy, or want to sleep, or read, or be with your friend, they are as if they were not. When you want them, they are at your elbow, and ready for any enterprise. And the measure of your love they always return, heaped up."

From animals, ironically, Burroughs gained the companionship and acceptance that for years he had sought, but not received, from his wife. Ursula, strong willed like her husband, was as disapproving of his chosen profession as he was devoted to it. She continued to urge John to devote himself to conventional work, such as farming or business. Invariably, John bristled. After six of his books had been published, and he had earned wide respect as an author, he noted in his journal on October 22, 1885: "Mrs. B. advises me to give up writing and do something else for a living."

Burroughs didn't give up. During the 1880s, four new volumes were added to his oeuvre. The bulk of the essays that went into the books were written not in the study at Riverby, under the censorious eye of Mrs. Burroughs, but in a small outbuilding the author had constructed a few hundred feet from his back door. The new study was sided with rough, bark-covered

chestnut and contained a fireplace built of smooth stones. Burroughs furnished it with easy chairs, bookshelves, and a desk. Now he had a place to write and relax in peace. He called it the "Bark Study."

John Burroughs's sixth book and first of the decade, *Pepacton*, was published in 1881, shortly before the Bark Study was built. It was mostly a collection of nature essays, but also included a favorable review of the natural history references in Shakespeare and an off-beat travel narrative entitled "Pepacton: A Summer Voyage."

In the opening essay, also called "Pepacton," Burroughs described the boating trip he had taken down the Pepacton River, a tributary of the Delaware. His style in the piece—as in most of the hundreds of essays he would ultimately write—was clear, straightforward, and, as Burroughs once said himself, extemporaneous. In "Pepacton," he drifted with the current of his thoughts, as well as the current of the river, flowing from descriptive passages to philosophical asides and to points of natural history. During the journey, he struck up a friendship with two boys, Johnny and Denny.

It seems Denny had run away, a day or two before, to his uncle's, five miles above, and Johnny had been after him, and was bringing his prisoner home on a float; and it was hard to tell which was enjoying the fun most, the captor or the captured.

"Why did you run away?" said I to Denny.

"Oh, 'cause," replied he, with an air which said plainly, "The reasons are too numerous to mention."

"Boys, you know, will do sometimes," said Johnny, and he smiled upon his brother in a way that made me think they had a very good understanding on the subject. . . .

"Let's leave our floats here, and ride with him the rest of the way," said one to the other.

"All right; may we, mister?"

I assented, and we were soon afloat again. How they enjoyed the passage; how smooth it was; how the boat glided along; how quickly she felt the paddle! They admired her much; they praised my steersmanship; they praised my fish-pole and all my fixings down to my hateful rubber boots. When we stuck on the rifts, as we did several times, they leaped out quickly, with their bare feet and legs, and pushed us off. . . .

I tried them on a point of natural history. I had observed, coming along, a great many dead eels lying on the bottom of the river that I supposed had died of spear wounds. "No," said Johnny, "they are lamper-eels. They die as soon as they have built their nests and laid their eggs."

"Are you sure?"

"That's what they all say, and I know they are lampers."

So I fished one up out of the deep water with my paddle-blade and examined it; and sure enough it was a lamprey. . . .

"The lampers do not all die," said Denny, "because they do not all spawn," and I observed that the dead ones were all of one size and doubtless of the same age.

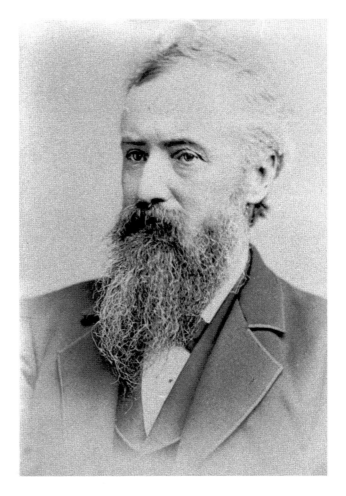

By 1881, when this photograph was made, Burroughs had published six books.

Burroughs and the boys drifted on, and just below a place called "Bark-a-boom" they parted. The account of the episode is typical of Burroughs's approach to the nature essay. He readily admitted the gaps in his knowledge to his readers, and even at the peak of his fame he was never too proud to reveal how the gaps were filled, even when they were filled by children.

Pepacton was a hit with readers, although at least one critic took exception. Thomas Wentworth Higginson, a nature essayist and competitor of John Burroughs, wrote in *The Nation* that although *Pepacton* was "one of Mr. Burroughs's best books," it was in part "a tilt against his fellow authors." In an essay called "Nature and the Poets," Burroughs had taken

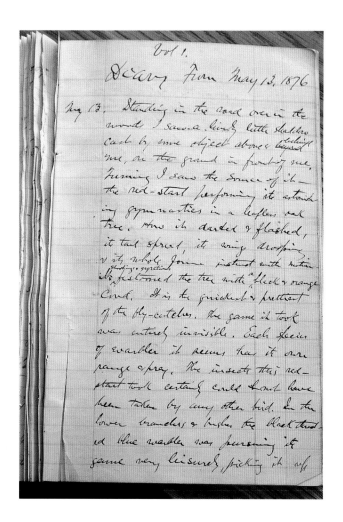

Burroughs began keeping a regular journal in a plain notebook on May 13, 1876. For more than forty years, he recorded nature observations, noted the comings and goings of his friends, and voiced joys and sorrows. The first entry (pictured here) describes an American redstart—a type of warbler—that he saw catching insects in the air near Riverby.

issue with some of the natural history contained in the poems of William Cullen Bryant and James Russell Lowell. Higginson was offended and accused Burroughs of "dogmatizing."

In 1884, Burroughs's next book, *Fresh Fields*, appeared. An eclectic collection of nature essays and travel pieces, *Fresh Fields* was inspired by a pleasure trip that John, Ursula, and Julian Burroughs had made to England in 1882. One essay, "A Hunt for the Nightingale," stands out particularly. Here Burroughs describes a solitary ramble through the English countryside during which he wandered for several days on foot from village to village, from inn to inn, seeking—with mounting frustration—to hear the singing of a nightingale. His chances were not good. It was late June—too late, most of the natives Burroughs met opined—to hear a bird known for singing only in spring. But Burroughs, determinedly hopeful, continued to ask every man, woman, and child he encountered.

I next met a man and a boy, a villager with a stovepipe hat on,—and, as it turned out, a man of many trades, tailor, barber, painter, etc.,—from Hazlemere. The absorbing inquiry [had the man heard a nightingale?] was put to him also. No, not that day, but a few mornings before he had. But he could easily call one out, if there were any about, as he could imitate them. Plucking a spear of grass, he adjusted it behind his teeth and startled me with the shrill, rapid notes he poured forth. I at once recognized its resemblance to the descriptions I had read of the opening part of the nightingale song,—what is called the "challenge." The boy said, and he himself averred, that it was an exact imitation. The chew, chew, chew, *and some other parts, were very bird-like, and I had no doubt were correct. I was astonished at the strong, piercing quality of the strain. It echoed in the woods and copses about, but, though oft repeated, brought forth no response. With this man I made an*

The writing desk in Burroughs's Bark Study, where John Burroughs wrote many of the thoughtful, easygoing essays enjoyed by countless readers.

engagement to take a walk that evening at eight o'clock along a certain route where he had heard plenty of nightingales but a few days before. He was confident he could call them out; so was I. . . .

At eight o'clock, the sun yet some distance above the horizon, I was at the door of the barber in Hazlemere. He led the way along one of those delightful footpaths with which this country is threaded, extending to a neighboring village several miles distant. It left the street at Hazlemere, cutting through the houses diagonally, as if the brick walls had made way for it, passed between gardens, through wickets, over stiles, across the highway and railroad, through cultivated fields and a gentleman's park, and on toward its destination,—a broad, well-kept path, that seemed to have the same inevitable right of way as a brook. I was told that it was repaired and looked after the same as the highway. Indeed, it was a public way, public to pedestrians only, and no man could stop or turn it aside. We followed it along the side of a steep hill, with copses and groves sweeping down into the valley below us. It was as wild and picturesque a spot as I had seen in England. The foxglove pierced the lower foliage and wild growths everywhere with its tall spires of purple flowers; the wild honeysuckle, with a ranker and coarser fragrance than our cultivated species, was just opening along the hedges. We paused here, and my guide blew his shrill call; he blew it again and again. How it awoke the echoes, and how it awoke all the other songsters! The valley below us and the slope beyond, which before were silent, were soon musical. The chaffinch, the robin, the blackbird, the thrush—the last the loudest and most copious—seemed to vie with each other and with the loud whistler above them. But we listened in vain for the nightingale's note. Twice my guide struck an attitude and said, impressively, "There! I believe I 'erd 'er." But we were obliged to give it up. A shower came on, and after it had passed we moved to another part of the landscape and repeated our call, but got no response, and as darkness set in we returned to the village.

The epic search continued, and when it was over, Burroughs still had not heard a nightingale. But he was not bitter. Along the way Burroughs had found much humor, suspense, and local color, and he soon fashioned them into an essay that stands among his best.

In 1885, a new Democratic government replaced the old Republican administration in Washington, and Burroughs found himself out of a job. Now that his services as bank examiner were no longer required, he could devote all of his time to writing, rambling, and viticulture.

A new volume of Burroughs's nature essays called *Signs and Seasons* appeared in 1886. The author, who struggled on and off with depression through the second half of the decade, wrote to Walt Whitman in Camden, New Jersey, just before the work was published. "I do not think much of it—the poorest of my books, I think."

Perhaps Burroughs, who was now forty-nine, was right. The essays lacked some of the youthful enthusiasm and humor of his earlier works. But while much of *Signs and Seasons* lacked the author's trademark high spirits, we see emerging from its pages a new Burroughs—a deeper, more spiritual man who was less an observer and critic, and more a philosopher.

The new tone was immediately apparent. On the first page of the first essay, Burroughs wrote:

One has only to sit down in the woods or the fields, or by the shore of the river or the lake and nearly everything of interest will come round to him,—the birds, the animals, the insects; and presently, after his eye has got accustomed to the light and shade, he will probably see some plant or flower that he has sought in vain. . . . So, on a large scale, the student and lover of nature has this advantage over people who gad up and down the world, seeking some novelty or excitement; he has only to stay at home and see the procession pass.

The great globe swings around to him like a revolving show-case; the change of seasons is like the passage of strange and new countries; the zones of the earth, with all their beauties and marvels, pass one's door, and linger long in the passing.

Signs and Seasons appeared in the middle of America's industrial revolution. Without consciously attempting to do so, Burroughs had published a blueprint for simple living that ran counter to society's prevailing winds. Thoreau and a few other writers had expressed similar ideas, but no one until Burroughs had presented them in such homely, comprehensible terms. With *Signs and Seasons*, Burroughs began to fill a role that he would play (and take seriously) for the rest of his days: that of an advocate of simple, joyous living.

While Burroughs was busy promoting the simple life, his existence at home grew suddenly more complex. Julian, eight years old, came home from school crying. For several days, it seems, his classmates had been taunting him that he bore a striking resemblance to his father, even though it was widely known that Julian had been adopted. On this particular day he had been called a bastard.

For Burroughs the hour of reckoning had arrived. Until this point he had shared the truth with only a few select confidants. (A journal entry for April 15, 1880, for example, finds Burroughs making maple sugar on his parents' Roxbury farm, and reports, "Father came up [to the pasture where Burroughs was working] and we sat on the wood-pile and talked and I told him about Julian.") Now, however, Julian was suffering and the truth could no longer be withheld.

Sometime in the middle of December, 1886, Burroughs told his wife the real story of Julian's origins. She exploded in a rage which was quite understandable given the circumstances, and for several weeks the house was in an uproar. In Burroughs's jour-

nal, references to the episode are frequent but indirect. A December 17 entry, for example, begins with remarks on the weather, then notes: "A domestic storm for several days and nights; only slept three or four hours last night for wife's tongue; all about Julian." The next mention appears on December 29. "Earthquake shocks still continue, now mild, now severe." On New Year's Day the ground under Burroughs's feet was still unsteady. "Rain and gloom," he wrote in the journal that day. "Earthquake shocks still pretty severe." Reading Burroughs's journal entries of this period, one might easily get the idea that Riverby was built on an active geologic fault.

Years after Burroughs's death, Elizabeth Burroughs Kelley found a remarkable document, a plain piece of paper on which her grandfather had written openly of his son's origins. The writing is in Burroughs's own hand, and for the first time in print I present its text, in full and without editing:

Mrs. B. says she [Dr. Anna Angell] lied to her, that she said she did not know the father of the child. If so that was a thoughtless & harmless lie; it did not influence Mrs. B.'s course. What she should have said was, Yes, I know the father but I cannot tell you who he is, I am not allowed to tell. Mrs. B.'s course of action would have been the same in any case. Was she wronged by putting my child upon her, instead of someone else's? I can't see it. But suppose she was, how about me? Would not that have been a wrong to me? No, all the lying in the case was done by me, & I think the end justified the means. I have no patience with that petty peanut morality [of Ursula] that would cheat a father of his child & the child of its home rather than tell a lie that harmed no one. Mrs. B. was deceived to her own good & to my good & to the child's good. I wish I had half a dozen boys like J. in the same [illegible word]. I am not at all repentant. Perhaps this is the shocking part. Well, I make no

Burroughs once described the song of a blue jay as "a medley of notes worthy of the mocking-bird, but delivered in a suppressed key—trills, quavers, warbles—very sweet and musical; occasionally there was a note like that of the red squirrel." He was keenly interested in bird songs and described them in extraordinary detail.

A flower of the tulip-tree, Liriodendron tulipfera. For Burroughs, trees were both complex organisms of great scientific interest and the landscape's most dramatic expression of the spark he called "the breath of life."

bones of it. When I write my autobiography I shall put it all in & more. I have no notion of ever being canonized as a Saint. Sinner John rather than St. John. The cowards in society are only stubble to be burnt up when they——

The closing metaphor was left incomplete. Ursula eventually accepted a fact that she could do nothing to change, and Julian, loved profoundly by both his parents, was consoled. Although his biological mother lived only a few miles away, Julian never made an effort to know her. For him, his only mother was Ursula.

Published in 1889, Burroughs's next book, *Indoor Studies*, continued the trend and was the most openly philosophical of his books to date. It was an intellectual smorgasbord of the author's thoughts on subjects such as Henry Thoreau, Gilbert White, solitude, fame, religion, and the meaning of life. The book contains some of Burroughs's best——and worst——writing.

Among the finest passages in *Indoor Studies* is a discussion of the absurdity of modern industrial life and a clear-headed analysis of the author's own literary style. Of life in the 1880s, Burroughs wrote:

Time has been saved, almost annihilated, by steam and electricity, yet where is the leisure? The more time we save, the less we have. The hurry of the machine passes into the man. We can outrun the wind and the storm, but . . . man becomes a mere tool, a cog or spoke or belt or spindle. More work is done, but in what does it all issue? Certainly not in beauty, in power, in finer men and women; but mostly in giving wealth and leisure to people who use them to publish their own unfitness. . . .

And on the author's casual approach to writing: "For my part, I never can interview Nature in the reporter fashion; I must camp and tramp with her to get any good [material], and what I get I absorb through my emotions rather than consciously gather through my

At Riverby, a grapevine bears ripening fruit. To supplement his income during the 1880s and 1890s, Burroughs grew table grapes and other fruits.

intellect. Hence the act of composition with me is a sort of self-exploration to see what hidden stores my mind holds."

Self-exploration, throughout Burroughs's career, occasionally resulted in essays that were shallow and impulsive——extemporaneous to the point that they lacked cohesion. In *Indoor Studies*, for example, he offered several pages of overheated, ill-considered criticism of Victor Hugo ("A Malformed Giant") and included a short piece on England ("Little Spoons vs

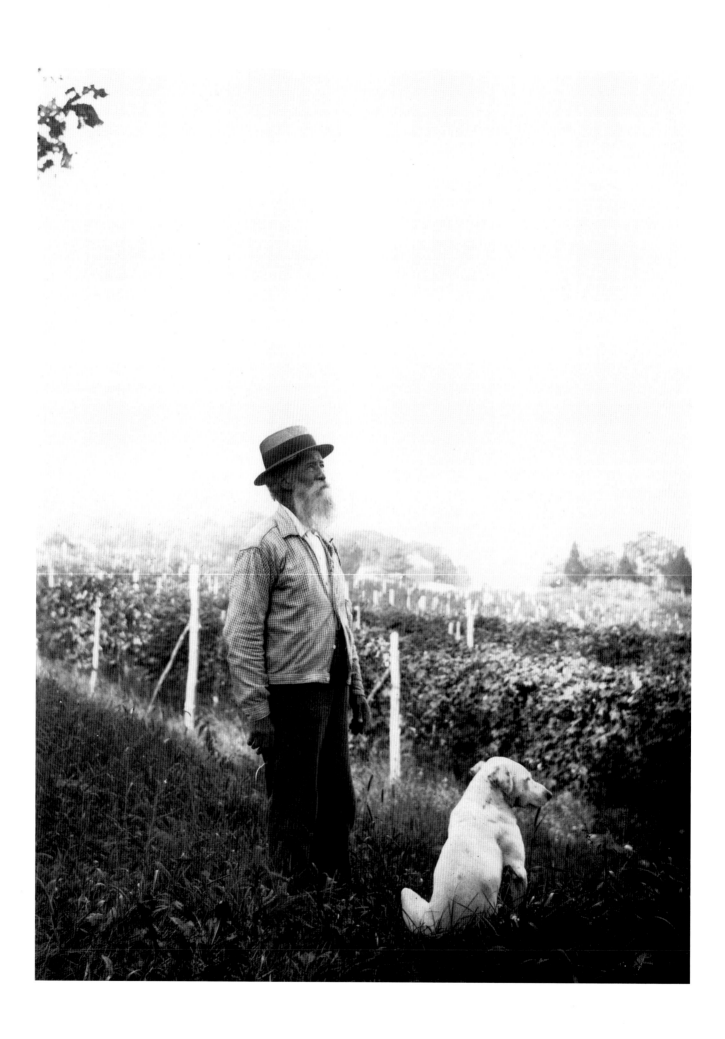

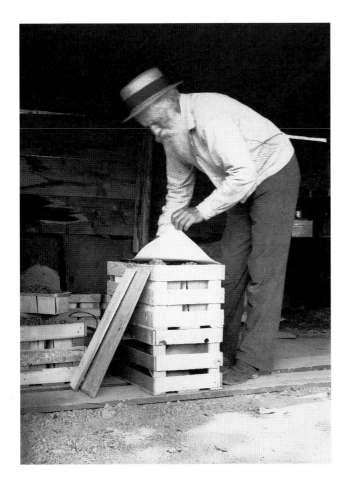

For Burroughs, the hard physical labor of clearing land, cultivating vines, harvesting fruit, and packing grapes for shipment provided a welcome change from the sedentary work of writing.

John Burroughs and a canine companion watch a hawk soaring over the Riverby vineyard.

Big Spoons") flawed by sweeping, unsupported generalizations. Burroughs's habit of including inferior essays among his best did little to undercut his popularity with readers, but it did much to weaken his work in the eyes of critics. No single volume by Burroughs has ever been hailed as a masterpiece on the order of Thoreau's *Walden.*

In 1887, Burroughs began to reach a new audience: America's schoolchildren. Mary Burt, a teacher at a public school in Chicago, had asked the local board of education to provide her class with thirty-six copies of *Pepacton.* She had a hunch that Burroughs's essays were clear and straightforward enough for children to read, and she believed that children would respond to them with far more enthusiasm than they brought to standard readers.

Burt's theory proved correct. The children in her classes devoured the essays hungrily. Oscar Houghton, Burroughs's publisher, saw commercial potential in Burt's experiment and commissioned her to edit a Burroughs anthology for children. The resulting book was the first of several Burroughs readers to be published. Its title was *Birds and Bees.*

As children in rural and city schools from coast to coast were making their acquaintance with Burroughs, the fifty-one-year-old author was busy working in his vineyards. In 1890, with the aim of rejuvenating his sluggish spirits through hard outdoor labor, Burroughs added nine acres to the Riverby property. He spent the spring of that year dynamiting apple stumps out of the new land, repairing the damage done to grape trellises by the Blizzard of '88, and preparing the soil for plantings. By year's end, he had put in an additional 2,400 grapevines, 2,000 currant bushes, and 2,000 hills of raspberries. Before long, John Burroughs's yields, and spirits, were improving. In 1891, the Riverby vineyards shipped out twenty-one tons of fruit.

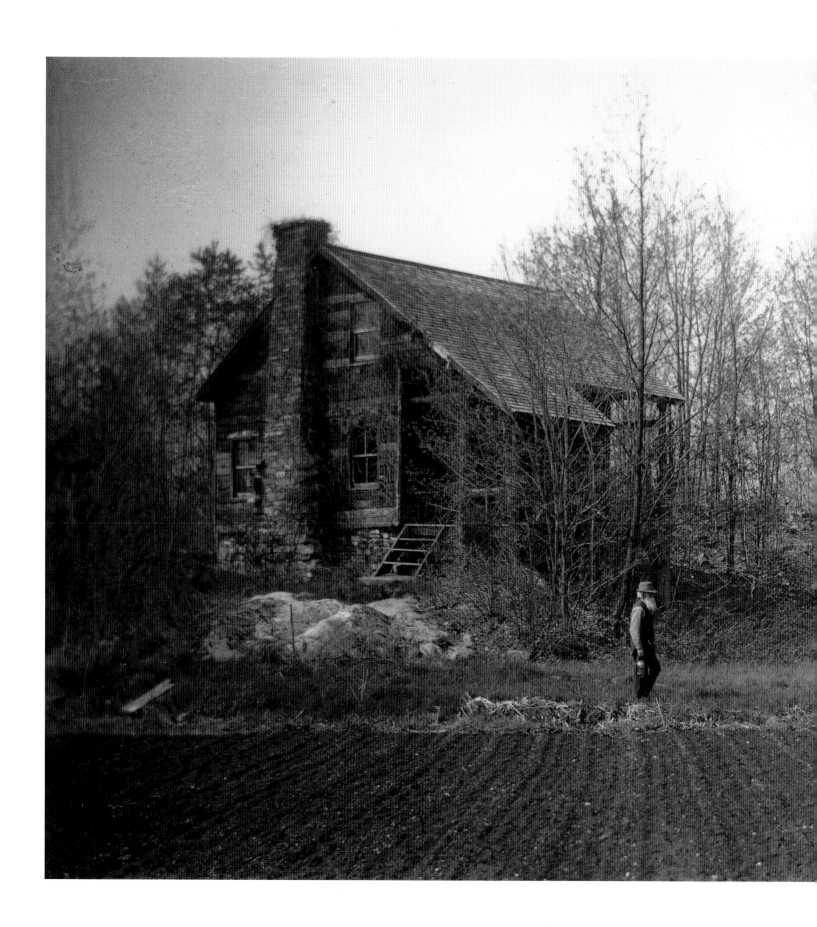

Burroughs's books, although they sold well, were not making him wealthy. They earned modest royalties (which the author opted to receive in the form of a small annual stipend), and now that bank-receiving was behind him, Burroughs still needed the income from his frequent contributions to periodicals to keep his wife, son, and himself housed, clothed, and fed. But the books attracted admirers, many of whom became Burroughs's friends.

One of those who made the transition from admirer to friend was Theodore Roosevelt. Burroughs and Roosevelt first met in 1889. The future president, then thirty years old, had read Burroughs's essays while traveling in England, and he told Burroughs that his descriptions of American scenes and wildlife had made him homesick. Despite vast differences in upbringing, Burroughs and Roosevelt had much in common. Both were successful authors and accomplished naturalists, and both were committed humanists who believed that man, despite his transgressions against nature, was a positive force on the planet. Until Roosevelt's death in 1919, the two men exchanged letters and visited each other frequently.

Another new friend of Burroughs's middle years was the Scottish-born, Wisconsin-educated naturalist John Muir. Muir and Burroughs first met in New York City in 1893. A year younger than Burroughs, Muir was an author of magazine articles but had yet to publish his first book. He lived in California and was fast gaining fame as a proponent of creating national parks and conserving American forests.

The friendship that developed between Burroughs, an easterner, and Muir, a confirmed man of the West, would eventually help to link conservation advocates

Burroughs walks by his celery patch.

Beginning with their first meeting, in New York, in 1893, John Burroughs and John Muir (right) enjoyed a long friendship. Burroughs encouraged Muir to preserve some of his ideas and adventures by writing books, and Muir regularly urged Burroughs to join him for travels in America and abroad. The two got to know each other well during the Harriman Alaska Expedition of 1899. Here they stand on what was already known as Muir Glacier on the Alaskan coast.

east and west of the Mississippi into a single powerful entity, a lobbying group with sufficient strength to battle the forces that actively opposed wilderness preservation—the timber, mining, and railroad interests. The beginnings of the alliance, however, were inauspicious. Muir was in Manhattan visiting a publisher interested in his writings. Burroughs was resting in a hotel the night after overindulging himself at a banquet. Muir visited Burroughs in his room, liked him at once, and invited Burroughs to join him on a European tour. Burroughs declined. Afterward, Muir wrote to his wife that Burroughs "seemed tired, and gave no sign of his fine qualities. . . . I can hardly say I have seen him at all." Burroughs's journal reported a "charming day" and described Muir as "an interesting man with the western look upon him" and "not quite enough penetration in his eyes."

That summer, Burroughs took a vacation from literary work and his Riverby vineyard to climb Slide Mountain, the highest peak in the Catskills. He recorded the ascent in an essay entitled, "The Heart of the Southern Catskills." Burroughs wrote: "Slide Mountain had been a summons and a challenge to me for many years. . . . But the seasons came and went, and my feet got no nimbler, until finally, one July, seconded by an energetic friend, we thought to bring Slide to terms."

Burroughs and his companion did bring Slide to terms, and on the summit, as Burroughs records later in the essay, they relished their triumph:

We saw the world as the hawk or the balloonist sees it when he is three thousand feet in the air. How soft and flowing all the outlines of the hills and mountains beneath us looked! The forests dropped down and undulated away over them, covering them like a carpet. To the east we looked over the near-by Wittenberg range to the Hudson and beyond; to the south, Peak-o'-Moose, with its sharp crest, and Table Mountain, with its long level top, were the two conspicuous objects; in the west, Mt. Graham and Double Top, about three thousand eight hundred feet each, arrested the eye; while in our front to the north we looked over the top of Panther Mountain to the multitudinous peaks of the northern Catskills. All was mountain and forest on every hand. Civilization seemed to have done little more than to have scratched this rough, shaggy surface of the earth here and there. In any such view, the wild, the aboriginal, the geographical greatly predominate. The works of man dwindle, and the original features of the huge globe come out. Every single object or point is dwarfed; the valley of the Hudson is only a wrinkle in the earth's surface. You discover with a feeling of surprise that the great thing is the earth itself, which stretches away on every hand so far beyond your ken.

In "The Heart of the Southern Catskills," Burroughs once again demonstrated his gift for describing the emotional impact of a landscape in such a way that the reader feels he is gazing upon the scene himself.

Burroughs's vivid account of his adventures on Slide Mountain accompanied other essays in the same vein in his next book, *Riverby.* The new volume, published in 1894, marked a return to the sort of close-to-home nature writing that had made Burroughs popular. But in the preface, Burroughs told readers that *Riverby* was "probably [his] last collection of Out-of-Door papers. . . ." He was convinced that the book would be a turning point.

Respected Man of Letters

Julian Burroughs grew to be a bright and good-natured young man, the pride of his parents. Despite his unifying presence, however, the squabbles between John and Ursula continued. Living arrangements complicated matters. The stone house at Riverby proved impossible to keep at a comfortable temperature in cold weather, so in the late autumn of each year, Mrs. Burroughs rented winter quarters in Poughkeepsie. John stayed with her frequently but, preferring country life to the bustle of the town, often returned to Riverby, where he worked, relaxed, and slept beside the roaring fire in the Bark Study. Julian, struggling with divided loyalties, trudged back and forth between the two camps like a diplomat shuttling between uncertain allies.

Burroughs's journal recorded one side of the story. An entry in 1887 reported: "Finished Tom Jones this morning. Wife upbraids me for reading the book; can't see how a book with so much foulness in it can give me any pleasure." Then, as if to settle the score, Burroughs added, "Tom Jones is a great literary masterpiece." Ten years later, a journal entry from the mid-1890s showed that the situation at Riverby was little improved: "Reach home today at 10 A.M. The same old atmosphere of rangle-jangle. Mrs. B. mad because I went and mad because I came home."

When Burroughs built the Bark Study in 1881, he escaped from conflicts at home and found the peace he needed to work. But the refuge no longer served its purpose. Burroughs's rising popularity was attracting uninvited visitors—most of them admirers of his books—to Riverby in great numbers, and Burroughs could rarely bring himself to turn them away. His writing suffered. In 1895, seeking a solution that would not injure the feelings of his fans, Burroughs purchased twenty acres of land deep in the woods, about a mile west of Riverby. There, at the base of a steep cliff, by a swamp thick with red maple, poison sumac, and sassafras, he built a cabin with his own hands.

Burroughs framed the two-story structure with local timber. For siding, he

OPPOSITE: Beside the field-stone fireplace at Slabsides, John Burroughs entertained such friends as John Muir, Theodore Roosevelt, and Henry Ford.

A saw-whet owl with its prey.

nailed on bark-covered slabs of hemlock that he bought from a nearby sawmill. A neighbor looked the place over, admired the rough bark exterior which made the cabin look like a cross between a house and a wigwam, and suggested Burroughs call it "Slabsides." Burroughs liked the rustic sound of the name, and it stuck.

In the wet black soil of the swamp outside Slabsides, Burroughs aimed to grow celery as a cash crop. Inside, far from the censorious eyes of his wife, he wrote, read the books that interested him, and entertained visitors when he pleased. Slabsides had two bedrooms upstairs, a single bedroom downstairs, and a large common room fitted with bookshelves, a writing table, a dining area, and a fireplace broad and deep enough to cook in. Burroughs had built the fireplace and chimney from stones pried from a nearby cliff. To furnish the place, Burroughs collected branches and trunks in the surrounding woods, left the bark on them, and fashioned the pieces into rustic beds, cabinets, and tables.

Burroughs could devote so much time to building and equipping Slabsides, rather than laboring in the Riverby vineyard, because his grape crop that year had been almost completely destroyed by a July hailstorm. He finished mortaring the chimney on Christmas Eve.

Burroughs's chief literary accomplishment of 1895 had been the editing of a new, two-volume edition of *The Natural History of Selborne,* by the English naturalist Gilbert White. The books opened with an essay by Burroughs and were illustrated with photos and sketches of White's Hampshire, England haunts. "Many learned and elaborate treatises have sunk beneath the waves," Burroughs observed in his introduction, "upon which this cockle-shell of a book rides so safely and buoyantly." Burroughs went on to explain the essence of great nature-writing. "It requires no

great talent to go out in the fields or woods and de-
scribe in graceful sentences what one sees there—birds,
trees, flowers, streams, etc., but to give the atmosphere
of these things, to seize the significant and interesting
features and to put the reader into sympathetic com-
munication with them, that is another matter."

On April 18, 1896, Burroughs hiked into the
woods of "Whitman Land," as he called the area
around Slabsides, and set up housekeeping in his new
cabin. Accompanying him was Hiram, his eldest broth-
er. Mrs. Burroughs disapproved of Hiram, who was
poor and homeless, and resented her husband's charity
toward him. At Slabsides, Burroughs could entertain
Hiram as he pleased. The siblings spoke little to each
other, for Hiram was not a talker, but the presence of
the older man pleased John immensely. Together, the
brothers sat by the fire, rambled in the surrounding
woodlands, or worked beside the hired men in "the
muck swamp," as Burroughs called his celery patch.
That spring, the swamp would be planted with 30,000
celery seedlings.

Among the earliest visitors to Slabsides were Frank
Chapman, an ornithologist and bird protection advo-
cate from the American Museum of Natural History;
William Brewster, a prominent Massachusetts orni-
thologist; and the naturalist John Muir. Accompanied
by Julian, John Burroughs rowed across the Hudson to
meet Muir at the Hyde Park railway station. The three
crossed to Riverby, arriving after dark. According to an
account written long after the event by Julian's daugh-
ter, Elizabeth Kelley, the following interchange took
place:

"I'm going to have to take you to my cabin for the
night," said John Burroughs.

Muir responded with his trademark disdain for
civilized comforts. "Oh, anywhere in the woods."

Despite Muir's willingness to sleep outdoors,

*In partnership with his son, Julian, Burroughs raised a
young marsh hawk.*

Burroughs led the way through the dark forest to
Slabsides. There, they sat by the fireplace and talked
late into the night. In his journal, Burroughs described
Muir as "a poet and a seer" with "something ancient &
far away in the look of his eyes." He lamented that
Muir, who had described his adventures in the western
wilderness in fascinating detail, had no intentions of
writing about them. Muir "ought to be put into a
book," Burroughs wrote. "Doubtful if he ever puts
himself into one."

Burroughs turned sixty in 1897. He was in good
health and spirits. Although his literary output
had ebbed somewhat in the late 1890s, he had kept
busy with a variety of projects—writing essays for
periodicals, packing Julian off to Harvard, and labor-
ing in the vineyard. He also brought out a new volume
of essays on Walt Whitman. "To a loving interest in
Whitman and his work, which may indeed amount to
a one-sided enthusiasm, I plead guilty," Burroughs
admitted in the preface.

Whitman: A Study is a study in name only. In the eyes of Burroughs, Whitman was a godlike figure, loving of his friends, forgiving of his enemies, fearless, in touch with deep universal truths, and forever "sanguine." For Burroughs, Whitman was "the one mountain in our literary landscape," and *Leaves of Grass,* Whitman's foremost work, a "gospel." Throughout the volume, Burroughs made it clear that he viewed Whitman as the prophet of a new age, a figure comparable to, and perhaps even more important than, Jesus. Whitman, Burroughs asserted,

. . . sings a new song; he tastes a new joy in life. The earth is as divine as heaven, and there is no god more sacred than yourself. It is as if the world had been anew created, and Adam had once more been placed in the garden. . . .

. . . Hence we have in Whitman the whole human attitude towards the universe, towards God, towards life and death, towards good and evil, completely changed. . . . He sees good in all, beauty in all. It is not the old piety, it is the new faith; it is not the old worship, it is the new acceptance; not the old corroding religious pessimism, but the new scientific optimism.

He does not deny, he affirms; he does not criticise, he celebrates; his is not a call to repentance, it is a call to triumph.

Elevating *Whitman: A Study* above the level of ordinary hagiography are Burroughs's genuine passion for and thorough knowledge of his subject. Burroughs knew Whitman well—well enough, for example, that he could note that the poet "always had the look of a man who had just taken a bath"—and wrote of him with vigor and prescience. At a time when Whitman

Slabsides is as peaceful today as it was in 1900.

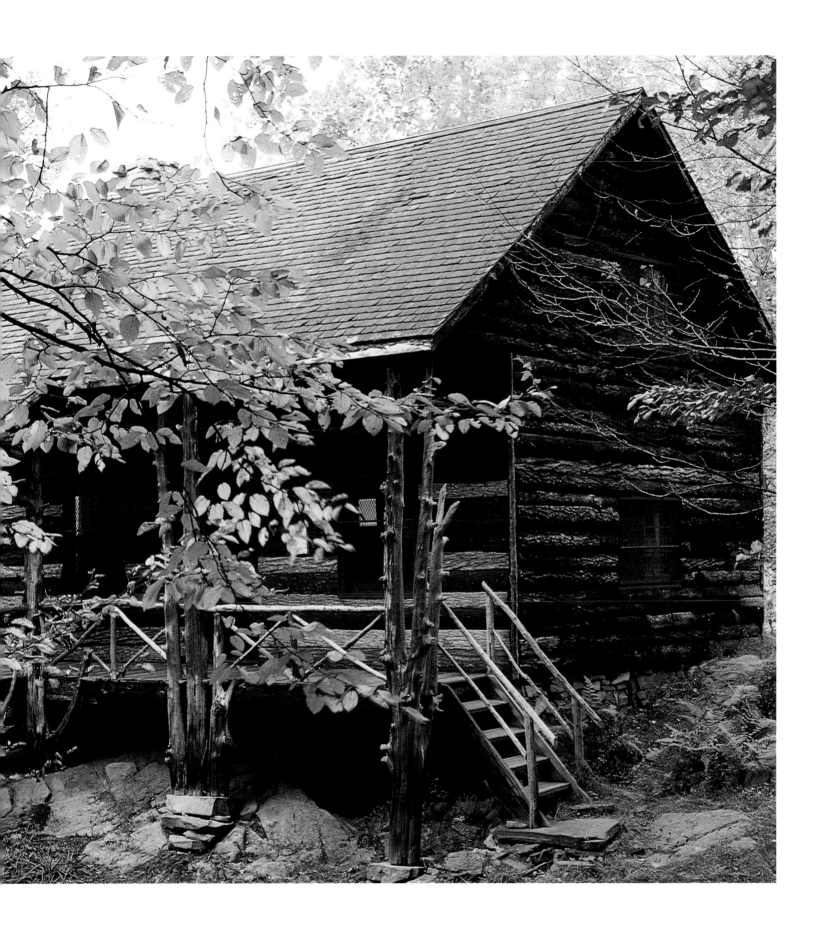

was still viewed widely as a third-rate poet, Burroughs wrote, "I predict a great future for Whitman."

Not long after the publication of *Whitman,* an article printed in the *New York Times*'s "Saturday Review of Books and Art" illuminated another side of Burroughs. According to the newspaper, John Burroughs and his neighbor, a Mr. Van Benschoten, had been suffering mysterious losses of fruit in their vineyards. The thefts became more frequent, and the viticulturalists grew angry. One dark night, armed with shotguns, Burroughs and Van Benschoten hid among Burroughs's Riverby trellises, hoping to catch a culprit red-handed. Their vigilance was rewarded. Two young men appeared and started to pick grapes. Brandishing the weapons, Burroughs and Van Berschoten pounced, captured the thieves, and held them captive until midnight. Burroughs might have been pleased if the story ended there, but it did not. The grape rustlers brought suit against Burroughs in a Poughkeepsie court, demanding damages of one thousand dollars apiece. They claimed that "Burroughs had accused them of grape-stealing in so loud a voice that it hurt their feelings."

Frustrations in the vineyard continued. Perhaps as a result, Burroughs, who during his middle years rarely ventured far from home, surprised even himself by accepting an offer to join a two-month scientific expedition to Alaska. The trip, which became known as the Harriman Alaska Expedition, was sponsored by Edward Henry Harriman, a New York financier and railroad magnate whose doctor had advised him to take a long pleasure cruise to get away from the stress of business and to relax in peaceful surroundings.

In a newly refitted steamship equipped with every contemporary luxury, Harriman steamed north from Seattle in the company of his family, his servants, and a crew of 114 officers, sailors, and companions. Among the companions were two dozen naturalists and artists, including such distinguished and destined-to-be-distinguished figures as the botanist William Trelease, the ornithologist Robert Ridgway, George Bird Grinnell, editor of *Forest and Stream* magazine, the explorer William H. Dall (for whom the Dall sheep was named), Henry Gannett, the U.S. Geological Survey's chief geographer, the mammalogist Clinton Hart Merriam, the bird painter Louis Agassiz Fuertes, the photographer Edward Curtis, John Burroughs, and John Muir.

Burroughs and Muir slept in adjacent staterooms. Although they had great respect for each other, the two men carried on a friendly feud throughout the voyage that proved entertaining for the Harrimans and the crew. For example, one day Muir led Harriman and a party of armed men into a valley where Muir had encountered bears and wolves on an earlier Alaskan trip. Muir had named the place "Howling Valley," and Harriman thought it would be an ideal place to shoot a bear. After miles of walking over difficult terrain, the party returned to the ship empty-handed. In his account of the event, Burroughs wrote: "There might not be any bears in Howling Valley after all—Muir's imagination may have done all the howling."

On another occasion, Burroughs stood admiring the Alaskan scenery from the deck while Muir was belowdecks, fraternizing with the crew. Later, when Muir came up for some air, Burroughs greeted his friend with a jibe. "You should have been out here fifteen minutes ago," Burroughs teased Muir, "instead of singing hymns in the cabin!"

At Slabsides, Burroughs wrote on a table he made himself from milled planks and sumac trunks.

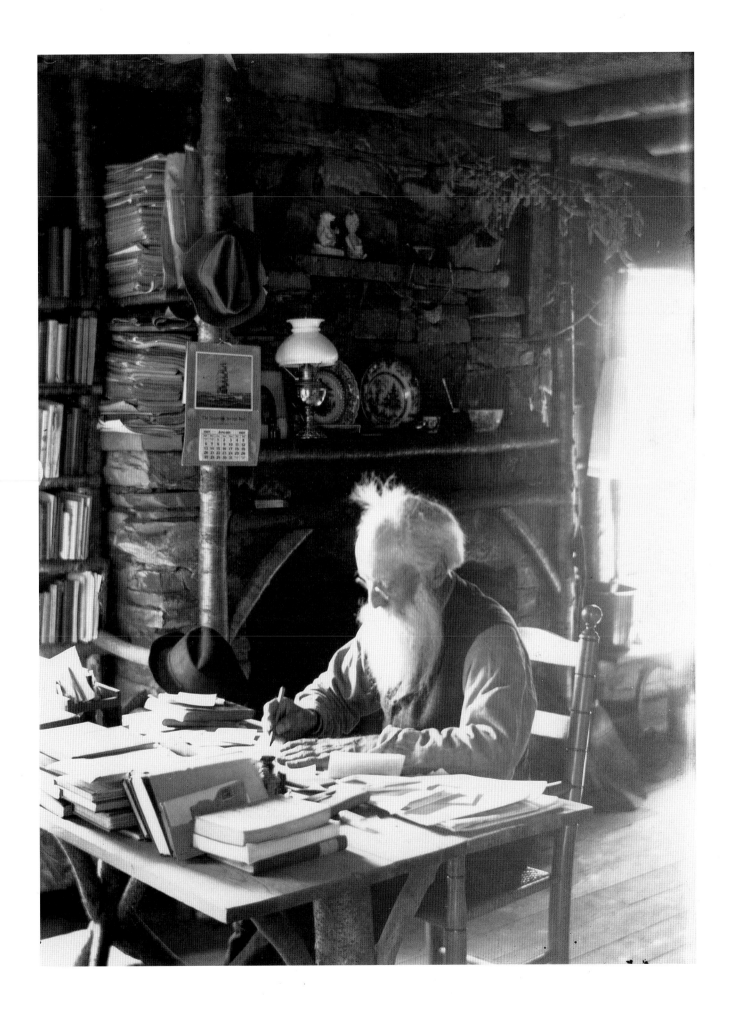

At Slabsides, John Burroughs served visitors meals at a plain wooden table. Standard fare included home-grown vegetables, steaks cooked in the fireplace, and water carried by bucket from a nearby spring.

LEFT: On a bed separated from the rest of the house by a palisade of yellow birch trunks, John Burroughs passed many happy nights at Slabsides.

"Aye, and you, Johnnie," said Muir, "ought to have been up here three years ago, instead of slumbering down there on the Hudson!"

The most amusing exchange between Burroughs and Muir occurred when the ship was docked at a village pier. Muir had convinced Harriman to forego a scheduled rest stop and instead to take the boat and its crew into the notoriously rough waters of the Bering Strait. Burroughs cringed. He had been seasick during much of the voyage and wanted no part of this side trip. He packed his bags and set off down the gangplank, planning to wait in the village until the boat returned and watch birds, search for wild-flowers, and socialize with a handsome widow he had met during an early visit ashore. But Muir inter-vened. He spied Burroughs making his escape, ac-cused him of cowardice, and dragged him back aboard the ship.

The episode inspired two poems—one by each of the principals. Burroughs wrote, in part:

> *Full of anger, full of spite,*
> *Strong in bluster, weak in might,*
> *Draped in fog both night and day,*
> *Barren sea!*
> *Only murres abide with thee.*
> *Had not John Muir put in his lip,*
> *Thou hadst not found me in this ship,*
> *Groaning on my narrow bed,*
> *Heaping curses on thy head,*
> *Wishing he were here instead—*
> *On green hills my feet would be,*
> *'Yond the reach of Muir and thee.*

Burroughs's poem was posted, with others of a similar vein, on a wall in the ship's dining room.

Muir responded in kind (and in part):

> *John B.*
> *Slabsides, he*
> *Said he could never love Behring* [sic] *Sea.*
> *And said it most doleful.*
> *Rhyming it soulful,*
> *Moaning it,*
> *Groaning it,*
> *Pa-thetic-alee*
>
> *My poor head is aching*
> *And every nerve quaking,*
> *And oh my interior,*
> *Grows queerier queerier,*
> *The sea's shaky all over,*
> *And its seals and its whales,*
> *And its gulls and its gales;*
> *Care nothing whatever for Slabsides or me!*

Despite their incessant jousting, Burroughs and Muir became fast friends. In the years following the expedition, they would exchange numerous letters, trav-el together on one more journey, and meet occasional-ly. At one point, Muir invited Burroughs to join him on an expedition through Africa and the Amazon. Burroughs declined, and Muir went alone, but immedi-ately upon returning to the United States, Muir made a surprise appearance at a social affair organized to honor Burroughs's seventy-fifth birthday.

Burroughs admired Muir, but he was no fan of his fellow nature-writers Ernest Thompson Seton and the Reverend William Long. In March, 1903, in an essay in *The Atlantic Monthly* entitled "Real and Sham Natural History," Burroughs made his disapproval public. Seton and Long, both authors of popular ani-mal stories, "seem to seek to profit by the popular love for the sensational and the improbable," wrote Burroughs. He conceded that the books of Seton and Long were entertaining but objected to them because

the stories they contained were peddled as genuine field studies.

To illustrate, Burroughs cited a recent volume by Seton, *Wild Animals I Have Known.* He said it might better have been titled *Wild Animals Only I Have Known.* Seton described a fox that rode the backs of sheep and on one memorable occasion lured a pack of hounds across a railroad track just in time for the dogs to be killed by a passing train. ("The presumption is that the fox had a watch and a timetable," said Burroughs.) These and other episodes, Burroughs asserted, showed that Seton's stories, while "true as romance, true in their power to entertain the young reader," were in fact bogus natural history. No one could separate the genuine observations in *Wild Animals* from the tall stories, Burroughs said, especially after reading Seton's opening statement: "These stories are true." Burroughs knew that Ernest Thompson Seton, despite the liber-

A barred owl in flight. "All the ways of the owl are ways of softness and duskiness," Burroughs wrote. "His wings are shod in silence, his plumage is edged with down."

ties he took with facts, was an experienced field natu-
ralist. Burroughs thought differently, however, about
the Reverend William Long, who, he opined, was the
"Munchausen of our nature-writers."

"Mr. Long's book [*School of the Woods*]," he wrote,
"reads like that of a man who has really never been to
the woods, but who sits in his study and cooks up
these yarns from things he has read." As an example,
Burroughs cited a Long story of a fox that was deter-
mined to catch several chickens perched beyond its
reach, high in a tree. Long wrote that the fox ran
around and around the tree until the chickens, having
grown dizzy from watching him, tumbled onto the
ground.

To balance his criticisms of Seton and Long, Bur-
roughs wrote approvingly of other popular nature writ-
ers—among them Bradford Torrey, Charles Dudley
Warner, Dallas Lore Sharp, Florence Merriam, Frank
Chapman, and Charles Roberts. He also noted that all
nature writers, including himself, risked "making too
much of what we see and describe."

Reactions to "Real and Sham Natural History"
came swiftly. Defenders of Seton and Long dismissed
the essay as the vitriolic utterance of an old man—a
"has-been" who had grown jealous of younger, more
able competitors. In May of 1903, *The North American
Review* published a rebuttal by Long. In it, the author
of *School of the Woods* claimed his work to be the
essence of "the recorded facts of twenty years patient
observation," and attacked Burroughs's own work,
including his literary essays. "He who would criticize,"
Long wrote, "must first learn courtesy." Seton,
unafraid of confrontation but shrewd enough not to
pit himself against the reputation of Burroughs,
responded to "Real and Sham Natural History" only
in his journal. Some years later, however, long after
Burroughs's death, Seton wrote an autobiography in

Burroughs celebrated the annual spring return of bluebirds
in "The Bluebird," a poem published in Bird and Bough
in 1906.

LEFT: *From youth to old age, Burroughs was an avid
trout fisherman. "I have been a seeker of trout from my
boyhood," he told readers in* Locusts and Wild Honey,
*"and on all the expeditions in which this fish has been the
ostensible purpose I have brought home more game than
my creel showed." Here, a fisherman casts for trout on
one of Burroughs's favorite stretches of water, the Esopus
River, in the Catskills.*

which he claimed that Burroughs had withdrawn his criticism and apologized to Seton in print. Seton quoted Burroughs: "Mr. Thompson Seton, as an artist and raconteur, ranks by far the highest in this field; he is truly delightful." Again, Seton had stretched the truth. Burroughs had actually written, ". . . to those who can separate the fact from the fiction in his work, he is truly delightful."

In books, in periodicals, and in the press, the battle between Burroughs and his allies, and Seton and Long and theirs, continued to rage. Eventually, President Theodore Roosevelt joined in, attacking the writers Burroughs had criticized and calling them "the Nature fakirs."

The fracas that Burroughs started had several important results. The Reverend William Long continued to write the same sorts of books, and persisted in his claims that they were factual. His career, however, went into a decline from which it never recovered. Seton shifted to a more scientific style of writing and illustrating. As years passed, he rose steadily in the public's esteem and went on to write his strongest works, including the much praised, multi-volume *Lives of the Game Animals.* After Burroughs's death, Seton won American nature writing's greatest honor—the John Burroughs Medal.

Although his public quarrels with Long and Seton brought Burroughs a few enemies, the nature faking controversy served chiefly to strengthen and widen his circle of friendships. In 1903, Theodore Roosevelt took Burroughs along on a camping trip to Yellow-

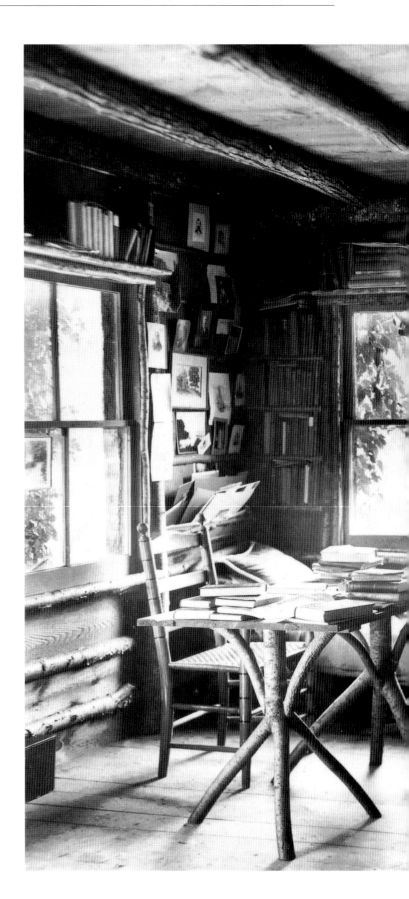

At Slabsides, where he spent countless hours before the fireplace staring into the embers, Burroughs's writings took an increasingly philosophical tone.

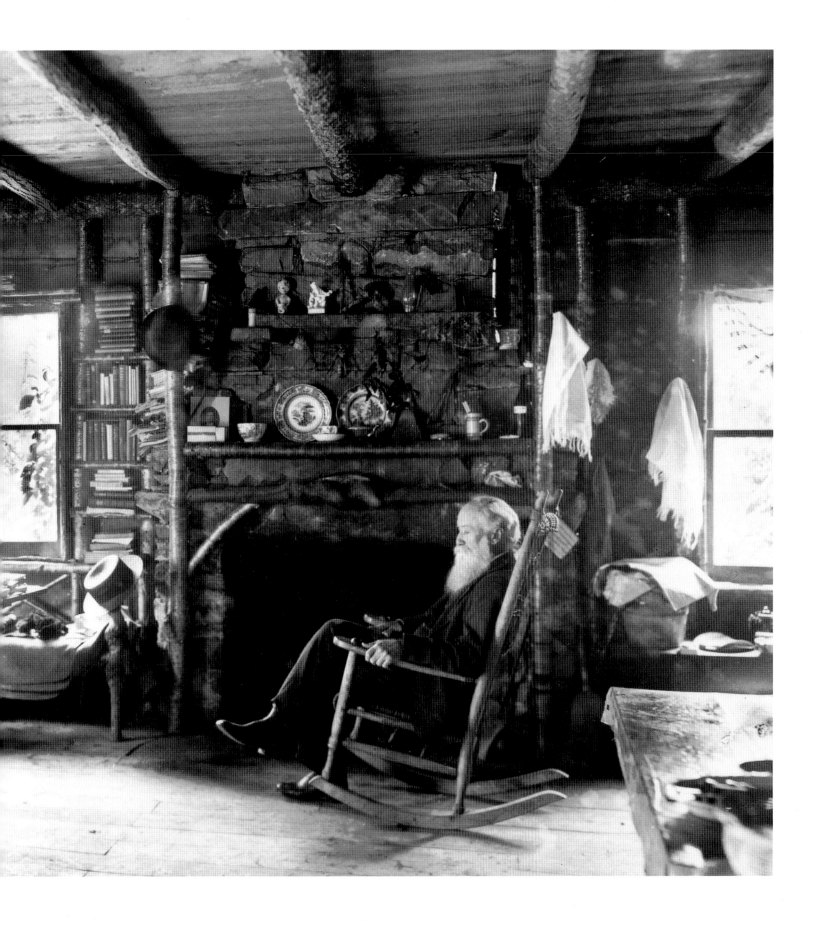

stone National Park and later in the year, he sailed the presidential yacht (the era's equivalent of Air Force One) up the Hudson to visit Burroughs at Slabsides. Burroughs fondly called Roosevelt "His Transparency," and Roosevelt called Burroughs "Oom John," meaning "Uncle John." The President's next book was titled *Outdoor Pastimes of an American Hunter,* and it was dedicated to Burroughs. "It is a good thing for our people that you should have lived," Roosevelt wrote of Burroughs, adding, lest there be any doubt about his

position, "I wish to express my hearty appreciation of your warfare against the sham nature-writers."

As old friends drew closer, several new friends entered the life of John Burroughs. Among the most notable was Elbert Hubbard, an author, editor, and the founder of the Roycroft Shop, a small, somewhat eccentric publishing house in upstate New York. In 1901, after spending a day visiting Burroughs at Slabsides, Hubbard published a volume entitled *Old John Burroughs.* This compact, hardcover book was the

Hoofprints of the whitetail deer. Examining such tracks and gleaning their secrets, or recognizing in bits of blood and feather the capture of a songbird by a hawk, gave Burroughs much pleasure.

first ever to be written about, rather than by, Burroughs. In it, Hubbard celebrated the influence of Burroughs in popularizing nature study and conservation. He cited the example of an 1889 bill in the New York State Legislature that had proposed a ban on hunting deer with hounds. Deer were scarce in New York at the time; nevertheless the bill met great opposition because, as Hubbard explained it, there was little public support for wildlife conservation. Hubbard then pointed to a 1900 attempt by hunting interests to exempt an Adirondack county from the same ban. This time, New York State legislators were deluged by letters calling for the deer to be protected. Hubbard credited the dramatic rise in public interest in conservation to Burroughs.

Of Burroughs as a writer, Hubbard concluded: ". . . he is just as virile—just as original—as Thoreau, and unlike Thoreau, he has no antagonisms. He has made the fragmentary philosophy of Whitman a practical working gospel, and prepared the way for Bolles, Thompson Seton, Van Dyke, Skinner, and a hundred other strong writers; and for all that army of boys and girls and men and women who now hunt the woods with a camera instead of a gun. . . ."

Another important new friend to enter Burroughs's life at this time was Dr. Clara Barrus, a psychiatrist at the Middletown State Hospital in upstate New York. She wrote to Burroughs for the first time in May, 1901, praising his writings and professing agreement with his views on Walt Whitman. Burroughs responded to Barrus on May 26, beginning a lively correspondence between the two.

In late September, at Burroughs's urging, Dr. Barrus made her first visit to Slabsides. She appeared again in October, spending the night in the cabin while her host returned to Riverby. On the first of December, Burroughs repaid the visits by stopping in to see

Spirals appear in the seed head of a sunflower.

Dr. Barrus at the state hospital in Middletown.

It is difficult to follow the evolving relationship between Burroughs and Barrus without wondering if the two were romantically involved. Dr. Barrus, thirty-seven, unmarried, and an intelligent and determined woman, lavished upon Burroughs numerous attentions. And Burroughs received these attentions warmly.

The surviving correspondence between the two (now held in the archives of Vassar College) shows that Burroughs did fall in love with Barrus. It also reveals that Barrus, and later Burroughs himself, insisted that the relationship remain a friendship, not a full-blown *affaire de coeur* that could bring disastrous consequences. Burroughs and Barrus remained close and were frequent companions during the ensuing years,

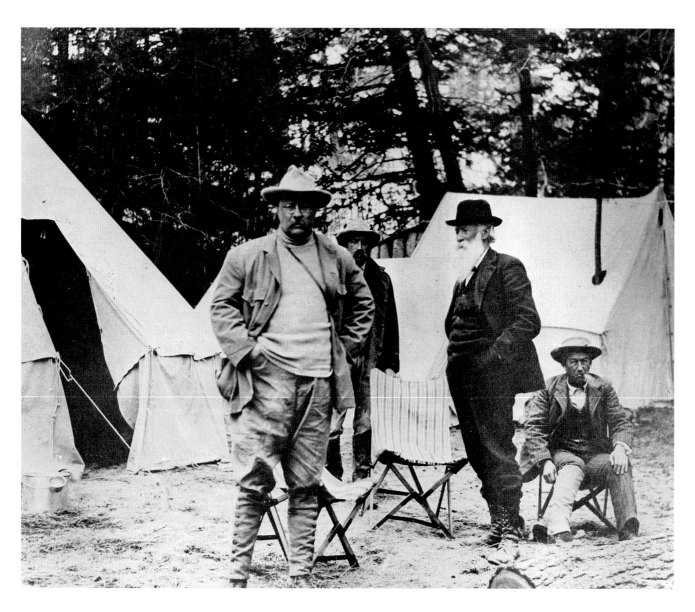

*Burroughs joined President Theodore Roosevelt on a
1903 camping trip to Yellowstone National Park. The
two men enjoyed each other's company immensely. The
president, himself an expert bird-watcher, was much
impressed by his companions's ornithological abilities. In
his book* Outdoor Pastimes of an American Hunter,
*Roosevelt recalled: "No bird escaped John Burroughs's eye;
no bird note escaped his ear."*

but throughout the period, Ursula Burroughs showed
tolerance and even affection for her prospective com-
petitor, and meanwhile, her own relationship with her
husband grew increasingly warm. When the Bur-
roughses traveled, Ursula often wrote to Barrus, keep-
ing her posted of the couple's health and whereabouts.
And in 1914, after Julian had moved away, Ursula
allowed Barrus to take up residence in a house on the
premises at Riverby. Despite the lack of a romance,
Clara Barrus made herself indispensable to John
Burroughs. On December 11, 1901, after Dr. Barrus
had found several minor errors in a manuscript he was
working on, Burroughs wrote to her: "If you will allow
me, I will send you all my proofs in the future."

Owing to his own good health and spirits, and
thanks to the typing, editing, and proofreading that
Clara Barrus began to perform for him, Burroughs was
extraordinarily productive during his sixties and seven-
ties. Between 1900 and 1908, he published five new
volumes of essays, wrote dozens of articles for periodi-
cals, brought out his first and only volume of poetry,
researched and authored a biography of John James
Audubon, edited a volume of English and American
nature poetry, and penned a slender volume describing
his 1903 adventures with President Roosevelt in
Yellowstone. In 1904, Houghton Mifflin published
the first limited, autographed edition of Burroughs's
works.

In the early years of the twentieth century,
Burroughs, who had spent most of his life avoiding
controversy, found it wherever he turned. Before the
nature faking controversy had even begun, he published
The Light of Day in 1900, a volume exploring the
meaning, if any, of life. Nearly every page contained a
direct attack on organized religion. "We must get rid
of the great moral governor, or head director,"
Burroughs wrote in one essay. "He is a fiction of our

*Photographed on the summit of Slide Mountain, this
Catskill porcupine is surely a descendant of the "porcu-
pigs" Burroughs encountered on Slide a century earlier.*

*NEXT PAGES: A ledge near Keene Valley, in the
Adirondack Mountains. "There is a fascination about
ledges!" Burroughs wrote. "They are an unmistakable fea-
ture, and give emphasis and character to the scene. I feel
their spell, and must pause awhile. Time, old as the hills
and older, looks out of their scarred and weather-worn
face. The woods are of today, but the ledges, in compari-
son, are of eternity. One pokes about them as he would
about ruins, and with something of the same feeling. They
are ruins of the fore world. Here the foundations of the
hills were laid; here the earth-giants wrought and builded.
They constrain one to silence and meditation; the whisper-
ing and rustling trees seem trivial and impertinent."*

Burroughs once described the April song of the American toad as sounding "the knell of Winter dead."

own brains. We must recognize only Nature, the All; call it God if we will, but divest it of all anthropological connections." At considerable risk to his popularity, Burroughs concluded, "The universe is no more a temple than it is a brothel or a library. The Cosmos knows no God—it is *super deum.*"

Despite the vehemence with which he expressed his views, Burroughs wrote about religion and man's place in the universe with considerable humor. Both paralleling and parodying some of his own writings on geology, he wrote that "the atmosphere of our time is fast being cleared of the fumes and deadly gases that arose during the carboniferous era of theology." There was no widespread condemnation of Burroughs and his views; on the contrary, during the first decade of the

new century his popularity seemed unassailable.

Burroughs's next volume, *Literary Values,* was published in 1902. It, too, was controversial but in a different way. This time the author took on the academic establishment, a move that won him few friends among critics. "Young men and young women actually go to college to take a course in Shakespeare or Chaucer or Dante or the Arthurian legends," wrote the self-educated, widely read Burroughs. He had sat in on several of Julian's classes at Harvard and was not pleased. "The minds of the pupils are focused upon every word and line of the text, as the microscope is focused upon a fly's foot in the laboratory. The class probably dissects a frog or a starfish one day, and a great poet the next, and it does both in about the same spirit."

John James Audubon appeared soon afterward in 1902. A biography of the pioneering American ornithologist, the book is Burroughs's least successful work, a fact he readily admitted. In agreeing to author *Audubon,* Burroughs had broken his rule of writing only from the heart. He had contracted to do the book for hire, and the result was a lackluster effort that he hoped would soon be forgotten. Despite its flaws, *John James Audubon* contained several good insights and some welcome touches of humor. For example, Burroughs said that Audubon's fame originated not from his knowledge of birds ("We have had better trained and more scientific ornithologists"), but from his "abandon and poetic fervour." At another point, Burroughs commented that Audubon's business career "consist[ed] mainly in getting rid of the fortune his father had left him."

In 1904 Burroughs published his next book, *Far and Near.* A return to nature writing, the opening section told of Burroughs's adventures in Alaska, and the closing chapter described a trip he had taken with Julian to Jamaica. Between were essays in the usual

Burroughs vein, among them "Wild Life About My Cabin," "New Gleanings in Old Fields," "Bird Life in Winter," and "August Days." In one story, Burroughs described how a young boy had proven him wrong on a point of natural history. In it, Burroughs wrote with wry humor how he had explained to the child that bluebirds nested only in meadows, and then, on a canoe trip with the child, found bluebirds raising young in the middle of a swamp. In "Wild Life About My Cabin," he wrote of eagles he had seen at Slabsides.

Many times during the season I have in my solitude a visit from the bald eagle. There is a dead tree near the summit, where he often perches, and which we call the "old eagle-tree." It is a pine, killed years ago by a thunderbolt—the bolt of Jove,—and now the bird of Jove hovers about it or sits upon it. I have little doubt that what attracted me to this spot attracts him,—the seclusion, the savageness, the elemental grandeur.

Burroughs was rarely satisfied to describe a scene; he was compelled to tell readers how the scene made him feel. After commenting on the declining numbers of eagles in the Hudson Valley, he concluded his thoughts on the eagle, writing,

I want . . . to feel the inspiration of his presence and noble bearing. I want my interest and sympathy to go with him in his continental voyaging up and down, and in his long, elevated flights to and from his eyrie upon the remote solitary cliffs. He draws great lines across the sky; he sees the forests like a carpet beneath him, he sees the hills and valleys as folds and wrinkles in a many-colored tapestry; he sees the river as a silver belt connecting remote horizons. We climb mountain-peaks to get a glimpse of the spectacle that is hourly spread out beneath him. Dignity, elevation, repose, are his. I would have my thoughts take as wide a sweep. I would

be as far removed from the petty cares and turmoils of this noisy and blustering world.

Burroughs never flew in an airplane, but by picturing what it would be like to see as the eagle sees, he soared in his own facile imagination.

In 1906, a collection of thirty-four of Burroughs's poems about birds and flowers appeared as a new book: *Bird and Bough.* With characteristic self-mockery, Burroughs demonstrated that his bravery under enemy fire could be heroic. In the preface he wrote, "Two or

Despite their frequent raids upon his Riverby fruit crop, crows were among Burroughs's favorite birds.

The emergence of pale, delicate flowers on the sugar maples announced to Burroughs that April, his natal month, had arrived.

A tulip-tree leaf unfolds on a spring morning. Burroughs once described spring: "A sort of luminous greenness everywhere; the young leaves seem to let the light through them a green transparency."

RIGHT: John Burroughs, born in April, loved spring above all seasons.

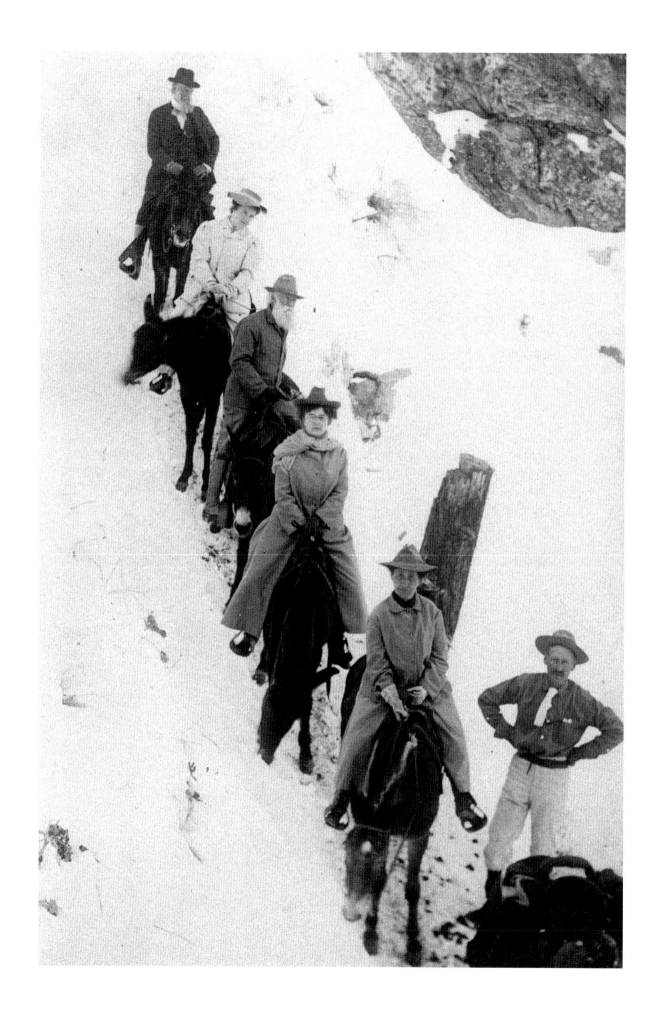

three years ago, a writer in one of the leading New York papers, commenting unfavorably upon some recent utterances of mine in one of the magazines, said that my readers could forgive me everything but my poetry. Now I am going to presume that some of them, at least, can forgive me even that."

The poems in *Bird and Bough* included "To the Lapland Longspur," "The Bluebird," and "Song of the Toad." Another poem about the common crow described in unexpectedly warm terms a bird that stole countless grapes from Burroughs's vineyards:

> My friend and neighbor through the year,
> Self-appointed overseer,
> Of my crops of fruit and grain,
> Of my woods and furrowed plain,
> Claim thy tithings right and left,
> I shall never call it theft.

No poem in *Bird and Bough* was a masterpiece, but all were deeply felt and rich in detail and humor.

On August 25, 1906, undoubtedly to Burroughs's satisfaction, *The New York Times* gave the book a warm review.

For Burroughs, the first decade of the new century closed with a great event—a trip with John Muir. Together the two old friends visited the Petrified Fo-rest, the Grand Canyon, and Yosemite Valley. Picking up where they had left off in Alaska, Burroughs and Muir quarreled over points of natural history and baited each other incessantly. During a ride by mule train to the bottom of the Grand Canyon, Muir chided Burroughs for not taking the time to see the canyon properly, on foot. At Yosemite, Muir compared the terrain and its beauty to Bur-roughs's own Esopus valley and found the Esopus vastly deficient. Nonetheless, each man enjoyed the journey and the company immensely. When it was over, Muir remained in California, and Burroughs boarded a passenger liner bound for Honolulu.

During their 1909 travels together through Arizona and California, John Muir (in rear), John Burroughs (third from rear), and a party of friends and guides rode mules to the bottom of the Grand Canyon. Muir had insisted that the only proper way to see the "Divine Abyss," as Burroughs later called it, was on foot. Outvoted by Burroughs and the others, however, Muir followed along reluctantly, teasing his friend all along the way about the frivolity of exploring the canyon like ordinary tourists.

An American Institution

At seventy-three, John Burroughs was still feeling, and often behaving, like a boy. In Hawaii, not satisfied to lounge in a beach chair and watch young Polynesian men ride the towering Pacific waves, he climbed atop a surfboard himself, making, he admitted afterward, "a comical failure" of himself. On February 18, 1910, he wrote in his journal: "Joy in the universe, and keen curiosity about it all—that has been my religion. As I grow old, my joy and my interest in it increase. Less and less does the world of men interest me; more and more do my thoughts run to things universal and everlasting." Publicly and privately, Burroughs continued to relish life.

Such enthusiasms are contagious. Inevitably, Burroughs attracted people eager to share his pleasures. When he stayed at Slabsides or Riverby, he was deluged with visitors seeking to enjoy, if only for an hour or two, the simple outdoor life he described in his books. When he took to the rails, crowds met his train and staked out his hotels. At this time in his life, it seemed he was almost constantly being interviewed, photographed, asked for advice, honored, and probed for opinions on matters ranging from world war to the colors of birds' eggs.

For the most part, Burroughs enjoyed his celebrity. Although he was shy and socially uncomfortable, in the core of his being he also craved and reveled in human companionship. Whenever a crowd of Vassar girls appeared at Slabsides, asking him to lead them on a bird walk, he rarely turned them away. And with considerable pride, he accepted three honorary doctoral degrees: from Yale University in 1910, Colgate University in 1911, and the University of Georgia in 1915.

Of all the attentions bestowed upon Burroughs, probably none gave him deeper satisfaction than the adulation of children. To the young people of America, the naturalist was a hero—a sort of flesh-and-blood Santa Claus who shared their youthful fascination with every living thing that walked, crawled, flapped, slithered, or grew. On April 3, 1911 (Burroughs's seventy-fourth birthday), a letter by

OPPOSITE: Near Wood-chuck Lodge, Burroughs posed beside the clay model of a work in progress. The finished work can be seen today in the Burroughs exhibit at the American Museum of Natural History.

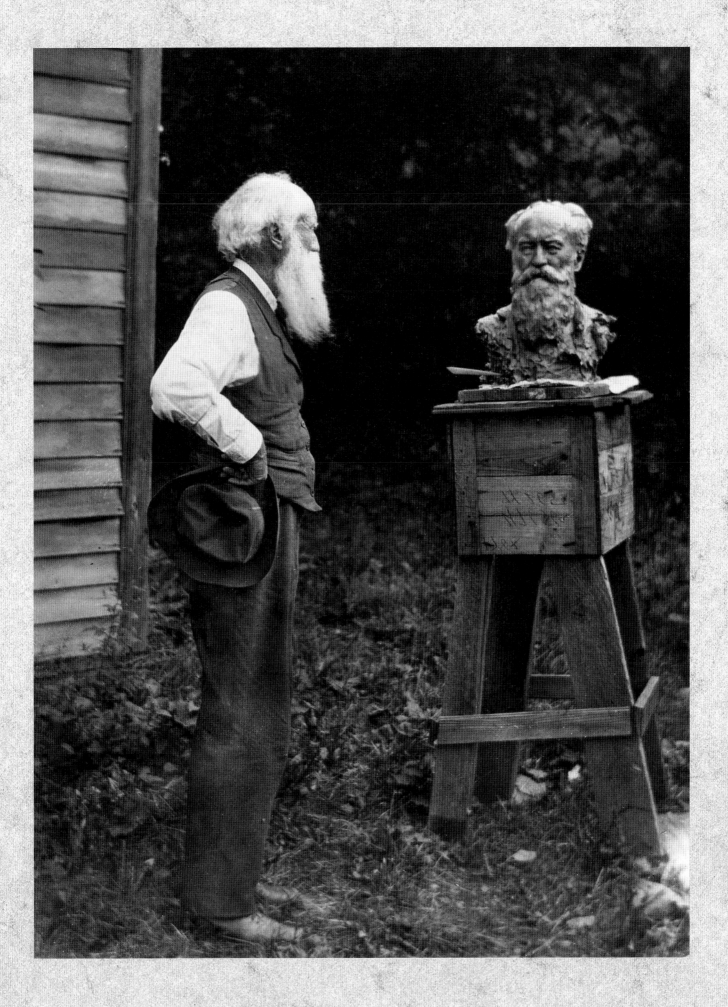

Burroughs to students was read aloud in every public school classroom in New York City. The following year, the American Museum of Natural History threw a birthday party in his honor. Its highlight was a parade of children, each one dressed in a different costume to represent a particular Burroughs book.

Burroughs's popularity was certainly not confined to New York. Wherever he traveled, children sought him out. In New Hampshire, he paused during an automobile journey to visit a sleepaway camp, where a crowd of boys and girls persuaded him to lead them on a nature walk. In 1984, after I had given a lecture on Burroughs, a girl who had joined in that ramble—now a woman in her seventies—spoke to me about Burroughs, whom she remembered as warm and softspoken. Her most vivid memory of him was lifting a honeybee from a flower with his gnarled fingers, showing the bee to the children, then letting the insect fly away unharmed. She remembered thinking that he must be the most gentle man in the world.

In 1918, a statue of Burroughs was unveiled in downtown Toledo. As Burroughs himself stood nearby, twenty thousand schoolchildren paraded before him, dropping wildflowers at his feet. By the time the ceremony ended, Burroughs had tears in his eyes and was ankle deep in blossoms.

During the last decade of his life, Burroughs added two household names to his lengthy roster of illustrious friends: Thomas Edison and Henry Ford. Independently at first, and later in tandem, Edison and Ford sought Burroughs's friendship. They wrote him appreciative letters, and motored to the Catskills to look him up at "Woodchuck Lodge," a house Burroughs had refitted for summer use on the old family farm. Beginning in 1913, the three men began to spend occasional holidays together. Later, they expand-

ed their party to include Harvey Firestone, founder of the Firestone Tire and Rubber Company.

Burroughs found much pleasure in the company of these men. At the winter home of Edison in Fort Myers, Florida, he wrote in his journal on March 10, 1914: "Edison and Ford good playfellows. Edison sleeps ten or twelve hours in the twenty-four; says he can store up enough sleep to last him for two years. A great mind—a great philosopher—loves jokes and good stories. Mr. Ford, a loveable man, a great machinist, but not the philosopher that Edison is; a shy, modest man, shrinks from any publicity and from those who would make a fuss over him. No vanity or conceit at all; he is not puffed up; thinketh no evil, has a good will for all. A real nature and bird lover, and lover of his kind."

Edison and Ford, on the other hand, saw Burroughs as a sage and treated him like a hero. At mealtimes, they placed Burroughs at the head of their table, and they rejoiced when he beat them in woodchopping contests (which he did routinely, even at the age of eighty-three). "No man," Ford wrote in his autobiography, "could help being the better for knowing John Burroughs."

The camping trips of Burroughs, Edison, Ford, and Firestone were much publicized. According to Edison's biographer Matthew Josephson, a story (probably fictional) circulated in newspapers about a

Six months after Burroughs received an automobile as a gift from Henry Ford, the two men met in Ford's Dearborn, Michigan, office. In his journal Burroughs wrote: "Mr. Ford pleased with me and I with him. His interest in birds is keen, and his knowledge considerable. A loveable man." A friendship took hold between the naturalist and the industrialist, lasting until Burroughs's death.

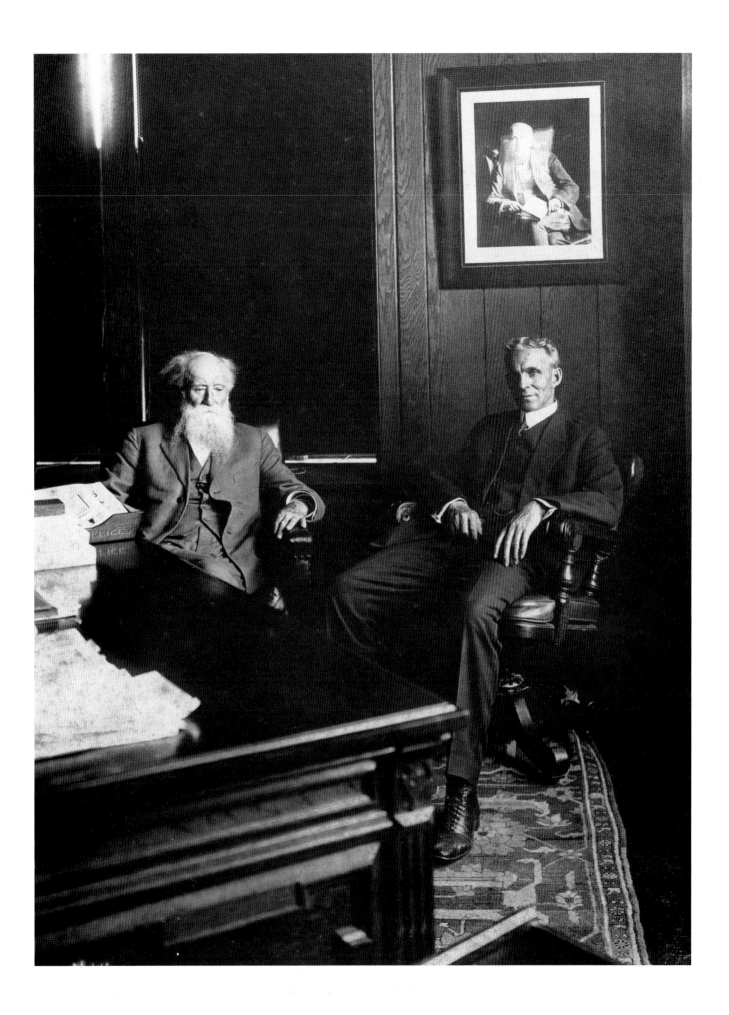

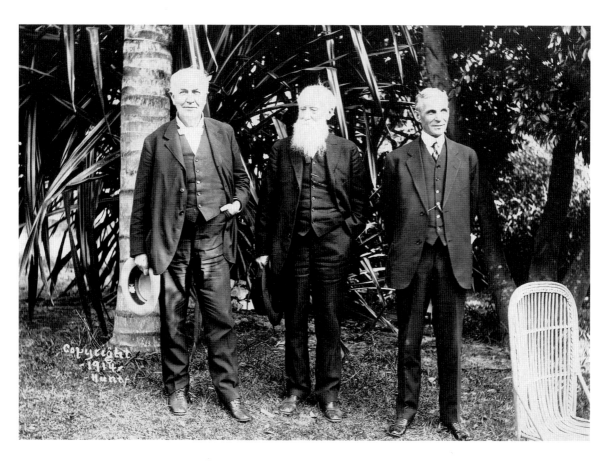

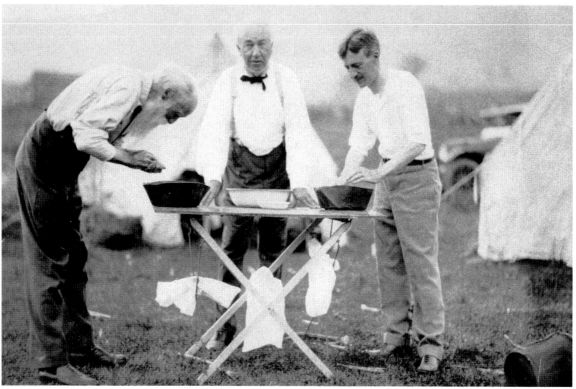

mechanical breakdown that the party's Model T Ford suffered in a small West Virginia town. When a local mechanic suggested to them that something was wrong with the motor, a voice rang out from the car. "I am Henry Ford," it said, and went on to assert that, although the car wasn't working at the moment, the engine was nevertheless in fine working order. The mechanic, a natural diplomat, shifted tack. Now he suggested that the car had an electrical problem. This time a new voice piped up from within. "I am Thomas Edison," it said. Edison, as the story goes, told the mechanic that the car's electrical system was in perfect condition. Exasperated, and no doubt convinced that he had been made the butt of a joke, the local man pointed to Burroughs. "And I suppose that must be Santa Claus!" he said.

For Burroughs, friendship with Henry Ford brought hazards as well as pleasures. In early 1913, aiming to prove to Burroughs that the advent of the automobile was a good thing, Ford presented the naturalist with a complimentary Model T. On May 13 of that year, Burroughs wrote in his journal: "Have just taken a run of a few miles in the car. The blind, des-

LEFT ABOVE: Among Burroughs's most devoted fans were Thomas Edison (left) and Henry Ford (right). In 1914, the great inventor and the powerful industrialist invited the nature writer to join them on a holiday in Florida.

During his last decade of life, Burroughs made several journeys by automobile caravan with Thomas Edison (center), the tire manufacturer Harvey Firestone (right), and Henry Ford (not pictured here). They slept in tents, competed against each other in wood-chopping contests (Burroughs usually won), and cooked in the open air. Much older than his companions, Burroughs found the trips good fun but inevitably returned home exhausted.

perate thing still scares me. How ready it is to take to the ditch, or a tree, or the fence!" In the years that followed, Burroughs drove far and often, but he never fully mastered the piloting of an automobile.

In 1912, Richard De Loach, a longtime fan of Burroughs and a frequent host to the naturalist in Georgia, published a 141-page volume entitled *Rambles with John Burroughs*. "The qualities of the man and his papers have always made a direct appeal to me," De Loach wrote in the book's preface, "and I love to come in contact with him and spend days with him. . . ." Some of De Loach's views harked back to Burroughs's appreciations of Whitman. "I find no other writer on Natural History themes," wrote De Loach, "quite up to Burroughs in honesty and keenness of observation, delicacy of sentiment, and eloquent simplicity of style."

At about the same time, Clara Barrus, who had cut back her own professional commitments in order to become Burroughs's full-time literary assistant, began work on an authorized biography. Although the finished product, an exhaustive two-volume *Life and Letters*, would not appear until 1925, four years after Burroughs's death, two derivative works were published during his lifetime. The first was *Our Friend John Burroughs*, published in 1914. The book was hagiography, but perhaps because it lacked the pretensions of objectivity which later plagued *Life and Letters*, it was well received. The highlight of the volume was a comic chapter about Barrus's western travels with Burroughs and Muir.

The second book, *John Burroughs, Boy and Man*, was printed just before Burroughs's death. In my view, it was Barrus's strongest work, and still stands as one of the most illuminating biographies of Burroughs. Rich in anecdote, light on adulation, and filled with dozens of stories recounted by Burroughs in conversa-

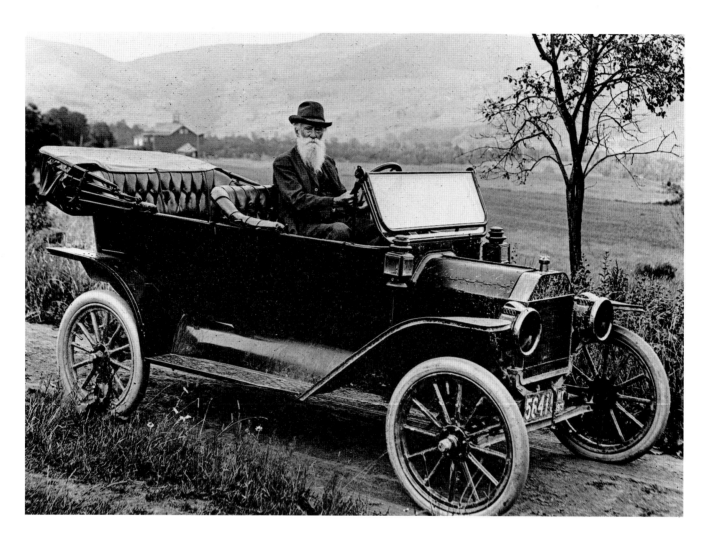

Burroughs was a better naturalist than a driver. Having
spent most of his years piloting vehicles pulled by horses, he
found automobiles—which needed constant vigilance to be
kept on course—difficult to get used to.

tion and correspondence, *John Burroughs, Boy and Man*
provided an especially vivid portrait of the naturalist's
youth in the Catskills.

Birthday celebrations, honorary degrees, new
friends, and flattering biographies do not tell the entire
story of Burroughs's last decade. Much sadness punc-
tuated his joys and triumphs. In May, 1912, Bur-
roughs's last surviving sister, Jane, died unexpectedly. A
month later, Curtis Burroughs—the brother who had
built Woodchuck Lodge—succumbed to a long illness.
When Eden, the youngest of the Burroughs brothers,
died several years later, John faced the sad chore of
burying the last of his nine siblings.

The naturalist also outlived many friends. John
Muir, a year younger than Burroughs, died in
December, 1915, his health having failed during a
long, fruitless battle to preserve Yosemite's Hetch-
Hetchy Valley. Burroughs learned of Muir's death on
Christmas Day. His journal records: "An event I have
been expecting and dreading for more than a year. . . .
A unique character—greater as a talker than as a
writer—he loved personal combat and shone in it. He
hated writing and composed with difficulty, though his
books have charm of style; but his talk came easily and
showed him at his best. I shall greatly miss him. . . ."

Three years later, Theodore Roosevelt, too, was
dead; and while Burroughs had expected Muir's death,
Roosevelt's came as a shock. Burroughs and the former
president had been at political odds for years—
Burroughs was a supporter of Woodrow Wilson, while
Roosevelt ardently was not—but their friendship had
never suffered. After "His Transparency" left office,
Burroughs continued to visit him at Sagamore Hill and
Pine Knot, Virginia. (Once, at the Roosevelts' summer
cabin at Pine Knot, the former president and Nobel
Peace Prize winner was called to Burroughs's bedcham-
ber during the night to subdue and carry off several

*Upon arriving back in the U.S. after an around-the-
world tour, John Muir made a surprise appearance at a
seventy-fifth birthday celebration for Burroughs in
Pelham, New York. Some writers have portrayed Muir
and Burroughs as bitter rivals, generally singling out one
of the pair as superior to the other. In fact, the two men
had deep respect for each other's work.*

flying squirrels that were sailing from wall to wall, keeping the naturalist awake.) Suddenly Roosevelt, who had always been so full of life, was dead. Burroughs wrote in his journal: "Heard of Roosevelt's death last night and have had a lump in my throat ever since. I love him more than I thought I did . . . and I remember his great kindness to me personally. The old man's tears come easily, and I can hardly speak his name without tears in my voice."

"When sorrows come, they come not single spies but in battalions," wrote Shakespeare. So it proved for John Burroughs. On November 9, 1916, less than a year after Muir's death, Mrs. Burroughs was examined at a hospital in Middletown, New York, and was found to suffer from cancer of the colon. "I had long ago made up my mind that she could not get well," Burroughs wrote in his journal that day, "but when they told me what they saw and that she could probably not live more than a month or 6 weeks, it came like a fresh blow. . . ." The doctors proved overly pessimistic in their estimate, but during the winter months, Ursula's condition worsened.

Although Burroughs and his wife had quarreled through much of their marriage, a peace had prevailed during their last years together. Julian had served as a peacemaker, and the arrival early in the century of three grandchildren—Elizabeth, Ursula, and John—had pulled the grandparents closer to each other than they had ever been. Celebrated from coast to coast and sought after by the rich and famous, Burroughs had at last convinced his wife that writing was a respectable vocation. Ursula, in her last years, grew more accepting of John's eccentricities, and perhaps he began to realize that his wife's ill health would eventually prove fatal. He knew that her loss would cut him deeply. Even the great honor that was bestowed upon him in the waning days of 1916—a gold medal for excellence in writing

During her final years, Ursula Burroughs's hard temperament softened, and she and her husband at last learned to get along peaceably. Ursula Burroughs died in 1917.

RIGHT: As Burroughs grew old, he returned with increasing frequency to the old family homestead in the Catskills. The visits were bittersweet because they stirred up so many memories of "a world apart," as he described it to a friend, "separated from the present by a gulf like that of sidereal space. The old farm bending over the hills and dipping down into the valleys, the woods, the streams, the springs, the mountains, and Father and Mother under whose wings I was so protected. . . ."

Looking uncannily like Santa Claus, a proud Burroughs holds his granddaughter, Elizabeth. "Betty" was the first of three children born to Julian Burroughs, the naturalist's son and only child.

from the American Institute of Arts and Letters—did little to raise his spirits.

As Ursula lingered, family and friends began to worry that John's own health was suffering. Henry Ford urged the naturalist to join him on a cruise to Cuba. At first Burroughs resisted, but the family, aware that Ursula would never recover but might hang on for months, persuaded him to go. Burroughs must have made a gloomy traveling companion. Not at all himself, he felt out of place, had little to say, and found only occasional interest in his surroundings. On February 21, 1917, he wrote in his journal, "My room [on the Ford yacht], 12 x 12 and sumptuously fitted up, joins the room of Mr. and Mrs. Ford, too fine for a Slabsider like me."

On March 7, a telegram brought Burroughs the news that Ursula was dead. "I am too much crushed to write about it now," he wrote in his journal. The full weight of losing Ursula did not settle over Burroughs until the following autumn, months after he had buried her at Tongore. Then at Riverby on October 24 he wrote these words: "Oh, the falling leaves! They move me. Her house is like a tomb. Felt her loss afresh when I went over to the kitchen door and found the leaves clustered there as if waiting for something. They were waiting for her broom. For over forty years it had not failed them, and now they lay there, dulled and discouraged. Oh, the unswept stones and entry-way—what a tale they tell!"

The sorrows that weighed on Burroughs in his old age were eased by hard work—a tonic he had once described to readers as the secret of happiness. In a spurt of productivity remarkable for a man of any age, Burroughs wrote eight books between 1910, the year he turned seventy-three, and 1921, the year he died. Two of the volumes were published posthumously.

Time and Change (1912) contained several chapters

on geology, a travel piece about Burroughs's journey in Hawaii ("the first trip at sea that ever gave me any pleasure"), and a series of contemplative essays with titles such as "Scientific Faith," "The Phantoms Behind Us," and "The Hazards of the Past." In the concluding chapter, "The Gospel of Nature," Burroughs explained that while he held the work of scientists in high esteem, he did not place himself among them. "I call myself a nature-lover and not a scientific naturalist," he wrote. "All that science has to tell me is welcome, is, indeed, eagerly sought for. I must know as well as feel. I am not merely contented . . . to enjoy what others understand. I must understand also; but above all things I must enjoy." Forever analyzing himself, trying to decipher and comprehend his own motivations and intentions, Burroughs invited readers to share in his own intellectual development. His excursions into his psyche were wonderfully free of artifice, and his writings about them possessed an openness that gave them charm.

A year later, *The Summit of the Years* was published. Burroughs wrote in the preface: "In publishing another volume of mixed essays, most of them written in the over-time I have made since I passed the Scriptural limit of three-score and ten years, I am cherishing the hope that my reader will not wish I had stopped at the boundary set by the Psalmist." Burroughs had little reason to fear. He was as popular as ever, and the essays in *The Summit of the Years* contained some of his finest writing. One piece entitled "A Barn-Door Outlook" began playfully: "I have a barn-door outlook because I have a hay-barn study, and I chose a hay-barn study because I wanted a barn-door outlook—a wide, near view into fields and woods and orchards where I could be on intimate terms with the wild life about me, and with free, open-air nature." At this stage in his career, Burroughs was doing much of his writing in Roxbury, in an old barn near Woodchuck Lodge.

Burroughs stands beside the mailbox at Woodchuck Lodge, a house on the Burroughs family farm at Roxbury. The naturalist renovated the lodge and used it as a summer residence during his last years.

NEXT PAGES: *On a cool fall morning, sugar maples frame Woodchuck Lodge.*

A detail of a shutter at Woodchuck Lodge.

There, using an old wooden crate for a desk, and seated before the open door of the hayloft, he read, wrote, and daydreamed. The tenor of his thoughts at the time is revealed in the opening essay of *The Summit of the Years.* "The longer I live," he wrote, "the more my mind dwells upon the beauty and wonder of the world."

Other chapters in *The Summit of the Years* contained light-hearted, yet accurate animal portraits of the sort that had made Burroughs's earlier books popular with children. For example, Burroughs's description of the red squirrel makes it seem the most appealing rodent alive:

> *No other of our wood-folk has such a facile, emotional tail as the red squirrel. It seems as if an electric current were running through it most of the time; it vibrates, it ripples, it curls, it jerks, it arches, it flattens; now it is like a plume in his cap; now it is a cloak around his shoulders; then it is an instrument to point and emphasize his states of emotional excitement; every movement of his body is seconded or reflected in his tail. . . .*

> *The gray squirrel comes and goes, but the red squirrel we have always with us. He will live where the gray will starve. He is a true American; he has nearly all the national traits—nervous energy, quickness, resourcefulness, pertness, not to say impudence and conceit. He is not altogether lovely or blameless. He makes war on the chipmunk, he is a robber of birds' nests, and is destructive of the orchard fruits. Nearly every man's hand is against him, yet he thrives, and long may he continue to do so!*

The next year, Burroughs helped Clara Barrus assemble materials for *Our Friend John Burroughs* but brought out no book of his own. Houghton Mifflin published *The Breath of Life,* his next book, in 1915. Over the years, Burroughs had expressed strong views

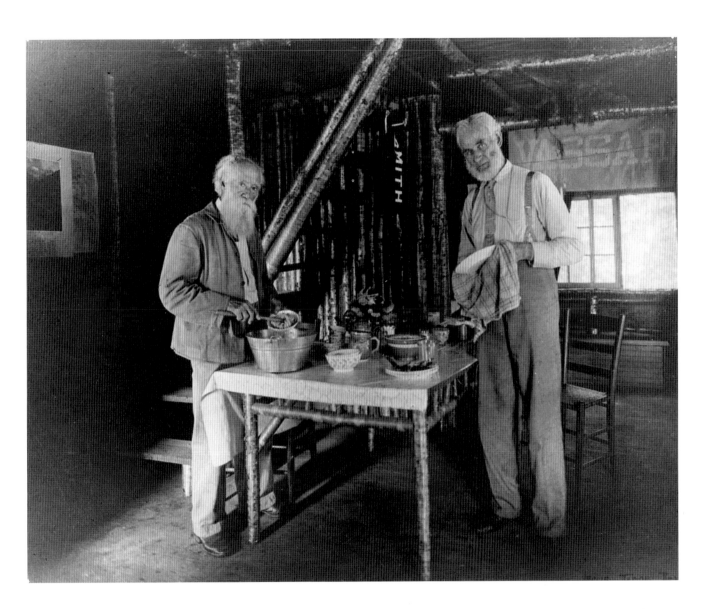

At Slabsides, Burroughs entertained distinguished guests such as Francis Fisher Browne, who was editor of The Dial, *a literary magazine to which Burroughs contributed essays.*

While ice still lingers on woodland ponds, a wood frog emerges to commence its courtship. The male swims through cold meltwater, serenading prospective mates with a guttural voice that resembles the quacking of a mallard duck.

on numerous subjects (especially when Walt Whitman was the topic of discussion), but he never grew rigid in his thinking. Seventy-eight years old when *The Breath of Life* appeared, he made it clear that his new book should not be read as a set of fixed views, but as an invitation to witness his thinking-in-progress on the greatest of mysteries—the miracle of life itself. "In these studies," he wrote in the preface, "I find I am about as far from mastering the mystery as the ant which I saw this morning industriously exploring a small section of the garden walk is from getting a clear idea of the geography of the North American continent."

In typical Burroughs style, *The Breath of Life* opened with an anecdote, a discussion of the weeds called burdocks that grew in Burroughs's garden. Year after year, Burroughs had tried to "scotch" them with a hoe, but the burdocks persisted, even when hacked savagely. Burroughs found himself admiring the sheer doggedness with which the plants renewed themselves

after his attacks and began to ponder the life force that inhabited burdocks and all living things. In the pages that followed, Burroughs pursued this "breath of life" tirelessly. In the process he developed his most unified series of essays on a single theme, showing how man's expanding knowledge of life's chemical basis could never rob a burdock or a *Homo sapiens* of its essential miraculousness.

The Breath of Life was widely acclaimed. The *American Library Association Booklist* called the book "the revelations of a mind and soul that have grown old beautifully." *The New York Times* wrote, "It [*The Breath of Life*] brings us closer to Mr. Burroughs himself, closer to a sane and fine intelligence and a lovable personality, and this alone will make it welcome to the naturalist's wide public." Of course not everyone agreed. The *North American Review* found that the book contained "little that is new or especially suggestive," and said it would have been "tedious" if "not for John Burroughs's poetic power."

Burroughs kept hard at work. In 1916, a year after he had contributed an article to the *Ladies Home Journal* entitled, "How I Can Do More Work at 77 than at 47," he brought out a new volume of essays, *Under the Apple Trees.* Typically, the essays took in a wide range of topics: songbirds ("In Warbler Time" had appeared in the premier issue of *Bird Lore,* the new magazine of the National Audubon Society), chipmunks, geology, the relationship of literature to science, and the writings of the French philosopher Henri Bergson. A fragment from an essay on the reproductive urge— "The Master Instinct"—shows Burroughs at the peak of his expressive powers.

Nearly all the animal orders below man are equally obsessed with the idea of perpetuating their species; for this they live, for this they die. It is a kind of madness; it leads to all kind of excesses and extravagances: bizarre colors and ornaments, grotesque forms and weapons, fantastic rites and ceremonies. The sexual instinct emboldens the timid, and spurs the sluggard; it sharpens the senses, it quickens the wits, it makes even the frogs and toads musical, and gives new life to the turtle. In fact, the drama of all life revolves around the breeding instinct. It is this that fills the world with music, color, perfume. The nuptials of the vegetable world are celebrated with lovely forms, brilliant hues, and sweet incense. With the birds they are attended by joyous songs, gay plumes, dances and festive reunions, and striking, if sometimes grotesque, forms. With the insects, music and gay colors mark the day; with the human race, how much of our song and art and pursuit of beauty has grown out of the instinct to please and win the opposite sex! Without this incentive—the mating instinct, the love of children, and of home and fireside—could we have attained to our present civilization?

Burroughs had a genius for illuminating the common ground hidden beneath widely disparate subjects, and in *Under the Apple Trees* we see this genius operating at full brightness.

It took Burroughs three years to get out his next

A spotted salamander, a retiring amphibian that spends most of the year underground, rests on a plush carpet of hair-cap moss. In an essay penned shortly before he died, Burroughs summed up his approach to salamanders, and indeed to all of nature and nature writing, in a single sturdy sentence: "I am less interested in the sermons in stones than I am in the life under the stones."

book—an unusually long interval between volumes for the prolific author, who was now eighty. He had been slowed by his wife's death, distracted by news dispatches from the war in Europe, and pulled away from his hayloft study to join a camping trip in the Smoky Mountains with Edison, Ford, and Firestone. Generally, however, Burroughs's health and spirits remained good. On January 1, 1918, he wrote in his journal: "The New Year finds me in pretty good health, writing in the morning, and sawing and splitting wood nearly an hour in [the] afternoon. More easily tired than one year ago, but my interest in the War, in Nature, in books, as keen as ever. Weigh about 132. Sight and hearing good, memory a little uncertain. Appetite as good as ever."

Field and Study, Burroughs's last set of nature essays published during his lifetime, appeared in 1919. By any measure it was not Burroughs's best work, but the volume was a remarkable accomplishment for an eighty-two-year-old. It included first-rate writing on crows, birch trees, house wrens, and foxes, to cite a few examples. In one essay, Burroughs buried an old hatchet by quoting Ernest Thompson Seton, his old nemesis from the nature faking controversy. In another, he used eloquent overview to generate interest in the detailed animal observations that would follow:

The migrating wild creatures, whether birds or beasts, always arrest the attention. They seem to link up animal life to the great currents of the globe. It is moving day on a continental scale. It is the call of the primal instinct to increase and multiply, suddenly setting in motion whole tribes and races. The first phoebe-bird, the first song sparrow, the first robin or bluebird in March or early April, is like the first ripple of the rising tide on the shore.

By shifting interest from a global phenomenon (migration) to backyard creatures such as the robin and the

bluebird, Burroughs demonstrated once more his mastery of the segue. He could begin an essay on one subject, switch to another, and to another again, and meld the three parts together with logic so compelling that they seemed all of a piece. *Field and Study* also revealed that Burroughs had lost none of the childlike curiosity that over the years earned him a vast circle of admirers. One cannot resist the appeal of pieces such as this:

The most amusing bluff that I know in wild nature is put up by the male wasp when you seize him in your hand and he makes believe sting. He goes through with an exact series of movements that ought to cause you to drop him as you would a red-hot coal. He curves his body and thrusts out the stinging end right and left viciously, feeling for a vulnerable place on your flesh and protruding a sort of stinger-scabbard minus the stinger. The sight of it all fairly makes one wince. Of course, he does not know he is bluffing, there is no such word in his dictionary, but he seems to think he is punishing

RIGHT, ABOVE: *Near slabsides, Burroughs and Farida Wiley, of the American Museum of Natural History, cook "brigand steaks"—the house specialty, something like shish kebab—over an open fire. Burroughs wears an overcoat made from the skins of Roxbury woodchucks. The photo was taken in the autumn of 1920 during one of Burroughs's last days at his cabin.*

On a warm day, Burroughs dines alfresco with (from left to right) Clara Barrus, Harriet Barrus, and a woman named Mrs. Stone. Barrus, a psychiatrist at a state mental hospital in Middletown, New York, was a literary assistant and frequent companion of Burroughs during his last years. Clara's niece, Harriet, was a favorite companion in adventure for Burroughs during the summers he spent at Woodchuck Lodge. She, her sister, Eleanor, Dr. Barrus, and Burroughs's granddaughter Ursula joined the naturalist on his last journey to California in 1920.

Burroughs and a young friend examine a summer wild-flower. Children were fond of Burroughs—and he was fond of them. In schools from New York to California, Burroughs's essays and poems about wildlife were enjoyed by children in their standard readers. During and after the naturalist's lifetime, a dozen or so schools across the country were named in his memory.

LEFT: Burroughs's celebrity brought crowds to Slabsides, taking a toll on the naturalist's time and energy. Here he poses on the cabin's steps with a contingent of admiring women from Vassar College.

you severely. It is as if a soldier in battle were firing blank cartridges without knowing it. You may know the male wasp by his yellow face. Beware of the black-faced ones.

Whether writing about wasps, woodchucks, or Whitman, Burroughs knew how to engage the reader's interest. He wrote with sincerity and simplicity, if not entirely artlessly, aiming, as he put it in *Field and Study*, to have his sentences "fit the mind as water fits the hand."

The reaction of critics to *Field and Study* was mixed. *The Boston Transcript* found it "a delightful volume," and *The New York Times* labeled it "a book full of interest and charm from beginning to end." But there were dissenting voices. In *The Dial*, a review opined, "We must prefer [the] accurate and telling description [of the book's first half] to the author's rambling, repetitious, intellectually undistinguished meditations [in the second half] on religion, science, evolution, nature, and natural history."

1920 was John Burroughs's last full year of life and it was an active one. In January, while passing the winter in southern California, he spoke to several school classes and nature clubs in La Jolla. In February, at the home of his friend Charles Lummis, he met Will Rogers and watched his famous rope tricks. In March, back at Riverby, he boiled maple sap over an open fire, just as he had as a child.

The final volume in Burroughs's oeuvre to appear while he was alive to see it was *Accepting the Universe* (1920). The forty-two short essays contained within give us Burroughs's last word on his personal philosophy—a way of looking at life that he described in the preface as "radical optimism." At the heart of the book was a remarkable plea for nature-worship, a summons for readers to abandon traditional religions that Burroughs saw as anachronisms in a scientific age:

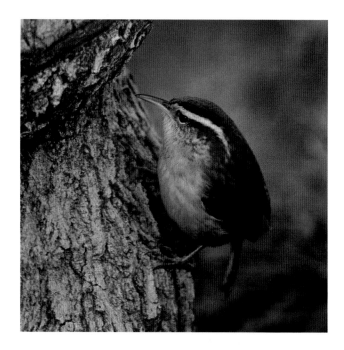

TOP: *"A Carolina wren—the only one I ever heard this side of Maryland—took up his position on the edge of the vineyard," Burroughs wrote to a friend in September, 1892, "and kept up his calls and warblings day after day, as if to mock me with the remembrance of my free and happy life years ago in Washington."*

A honeybee collects pollen from a zinnia. "Most persons think the bee gets honey from the flowers," wrote Burroughs, "but she does not: honey is a product of the bee; it is the nectar of the flowers with the bee added. What the bee gets from the flower is sweet water: this she puts through a process of her own and imparts to it her own quality."

When we call the power back of all 'God,' it smells of creeds and systems of superstition, intolerance, persecution; but when we call it Nature, it smells of spring and summer, of green fields and blooming groves, of birds and flowers and sky and stars. I admit that it smells of tornadoes and earthquakes, of jungles and wildernesses, of disease and death, too, but these things make it all the more real to us.

Burroughs advised readers to embrace the universe, to accept it wholeheartedly, as he had.

It ought not to be a hard thing to accept the universe, since it appears to be a fixture, and we have no choice in the matter; but I have found it worth while to look the gift in the mouth, and convince myself that it is really worth accepting. It were a pity to go through life with a suspicion in one's mind that it might have been a better universe, and that some wrong has been done us because we have no freedom of choice in the matter. The thought would add a twinge of bitterness to all our days.

Burroughs had enjoyed life immensely, and he believed that others, by choosing to love the world rather than worship a remote and abstract deity, could share the same pleasures he had found. "We must invest our fund of love, our veneration, our heroism, our martyrdom in this world," he wrote, "and not look to the next."

Burroughs celebrated his eighty-third birthday on April 3, 1920, at Yama Farms, a posh inn run by his friend Frank Seaman in Napanoch, New York. About forty close friends and relations attended the festivities. In the morning, Burroughs put on a maple-sugaring demonstration, and in the afternoon he planted a tree. Sometime during that weekend he also managed to slip away from the adult members of the crowd and lead a group of children to nearby Jenny Brook.

After giving a lecture on Burroughs to the

As Burroughs grew old, the view across the Hudson from his summerhouse, particularly of the grand Vanderbilt mansion, pleased him less and less: "In my boyhood, I used to look across the home valley and see at night the sugar camp-fire of Seymour Older in the woods on the side of the big mountain."

After giving a lecture on Burroughs to the Greenwich, Connecticut Historical Society, I was approached by a man in the audience. As a girl, the man's mother had lived at Yama Farms, where she had attended Burroughs's eighty-third birthday gala. Anita Foraste (in a subsequent interview) remembered Burroughs as warm and unaffected, and told me that the naturalist had led a group of children to a brook, and there told them a favorite rhyme: "I left my heart to Jenny Brook/I think she took it with a hook."

In the evening, Burroughs's eighty-third birthday party continued with a formal dinner, a cake with candles, a round of testimonials, and some impromptu remarks by the guest of honor himself. Clyde Fisher, a friend of Burroughs and a scientist at the American Museum of Natural History, ended the day with a showing of lantern slides.

During May and June, Burroughs worked on new essays. When he wasn't writing on the old wooden crate he used for a desk in his "haybarn study," he was roaming the woods and meadows, picking berries, or swinging a pick to help neighbors to widen the road that ran in front of Woodchuck Lodge. That summer, Burroughs received dozens of visitors, among them John Russell McCarthy, a young poet whose work he admired. When time allowed, he corresponded with friends and admirers, shot an occasional woodchuck for the dinner table, and listened to phonograph records on his Victrola. Julian Burroughs had presented the record player to his father as a gift.

As part of his eighty-third birthday party at Yama Farms, Burroughs demonstrated how to make sugar by boiling fresh maple sap. Burroughs always enjoyed the six weeks in March and April when the maple sap was harvested and processed. As a boy, he had earned money to buy books by selling sugar cakes he made himself.

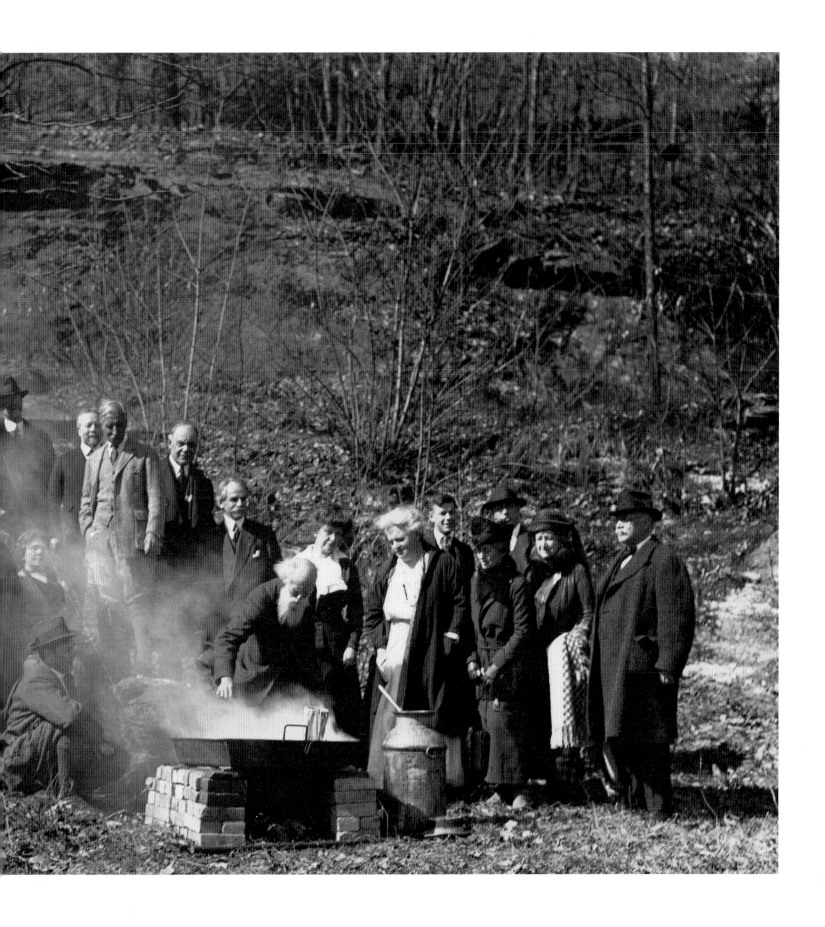

A worm-eating warbler at its nest.

LEFT: An ovenbird at nest. "I think one never sees a bird's-nest of any kind without fresh pleasure," Burroughs wrote. "It is such a charming secret, and is usually so well kept by the tree, or bank, or bit of ground that holds it; and then it is such a dainty and exquisite cradle or nursery amid its rough and wild surroundings."

A white-throated sparrow. Because of the endless pleasure he found in birds and the skill with which he described them, Burroughs was dubbed "John O'Birds" by the press.

began to fail. Preoccupied much of the time with death, Burroughs's journal began to report more about the naturalist's medicines and gastrointestinal languor than about the migrating birds and the autumn colors of the trees. On October 26, 1920, in the driveway of Woodchuck Lodge, Burroughs sat in his Ford listening attentively to Brahms's Lullaby, his favorite recording, playing inside on the Victrola. When the song ended, he drove away accompanied by Clara Barrus and her niece, Harriet. Burroughs would not see his Roxbury hills again.

Burroughs spent most of November at Riverby

and Slabsides. Then, as cold weather was setting in, he traveled west by rail through Toledo, Dearborn, Chicago, and Flagstaff, stopping off to visit friends along the route. He arrived in La Jolla, California, on December 3, and picked up a complimentary automobile that Henry Ford had sent from Los Angeles. His spirits and health were poor. Fortunately he was not alone. His granddaughter Ursula, Clara Barrus, and two of Dr. Barrus's nieces had come along to look after him and provide him company.

While his moods swung like a pendulum between extremes of cheer and despair, John Burroughs puttered around the cabin he had rented. He read occasionally, kept a fascinated eye on the trapdoor spiders that lived in the ground outside, and continued to write—journal entries, long lucid letters to friends and relatives back East, and essays on nature and literature. But melancholy returned again and again to darken his outlook. On January 8, 1921, Burroughs wrote in his journal: "Still, dry, bright, cold. White frost here this morning on roofs. A killing frost further north. The day fairly aches with the hard merciless light." On February 3, Burroughs and his companions moved to new quarters in Pasadena Glen. The next day he wrote the journal entry that proved to be his last. It concluded: "Life seems worth living again. Drove to Sierra Madre P.O. to-day. Now at 7 P.M. I hear the patter of rain."

Weak, disoriented, and suffering from an abscess on his chest, Burroughs entered a California hospital on February 17. A month later he emerged, little improved. His only interest was in returning home. As soon as it could be arranged, he was put on an eastbound train. He was accompanied by Clara Barrus, her nieces Harriet and Eleanor, and his granddaughter Ursula. They hoped to have him home in New York in time to celebrate his eighty-fourth birthday.

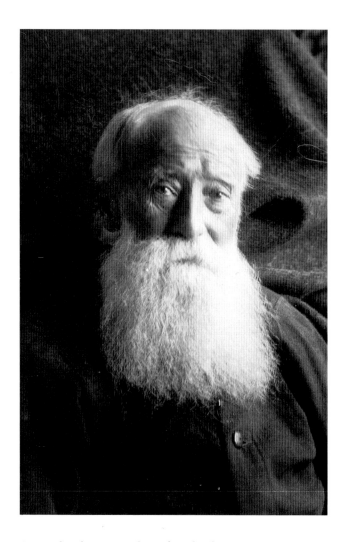

At age eighty-three, Burroughs posed for this photograph—his last—in March, 1921, in California. He was in failing health and died a few days later during the rail journey home to New York. In the last of his books published during his lifetime, Burroughs had written: "I shall not be imprisoned in that grave where you are to bury my body. I shall be diffused in great Nature, in the soil, in the air, in the sunshine, in the hearts of those who love me, in all the living and flowing currents of the world. . . ."

Late one night, as the train sped across Ohio, Burroughs awoke from a deep sleep. Harriet Barrus, who had been sitting by his bedside, asked if everything was all right. Burroughs whispered in her ear: "How near home are we?" A few seconds later he was dead.

As the sun rose that cold March day, morning newspapers across America and abroad spelled out the story. On the east coast, *The New York Times* devoted an entire page to Burroughs. It included a formal obituary, an artist's sketch spanning two columns, reactions to the news from important figures, and word that the New York State Senate had adjourned in Burroughs's honor. Henry Fairfield Osborn, a renowned conservationist and president of the American Museum of Natural History, called the death of John Burroughs "an irreparable loss." In West Orange, New Jersey, a subdued Thomas Edison told reporters, "Some of my most memorable hours were spent in the company of Burroughs."

"Public opinion enthusiastic and unanimous, has long accorded John Burroughs first place among American prose-poets of nature," opined Boston's *Evening Transcript.* "Possessing the qualities of Thoreau without the erratic temperament, and the qualities of Walt Whitman without the erotic, this venerable interpreter of the birds, the flowers, and the trees was a scholarly, philosophical and practical idealist . . . the marvel of his critics."

Each newspaper carried the story in its own way, each adding new details. Cleveland's *Plain Dealer* spoke with blunt eloquence. "A great American passes in the death of John Burroughs—not a statesman, or soldier, or a great scholar, but a great character whom millions loved." On the West Coast, *The Daily Times* of Los Angeles told of a resolution passed in Burroughs's honor by the California

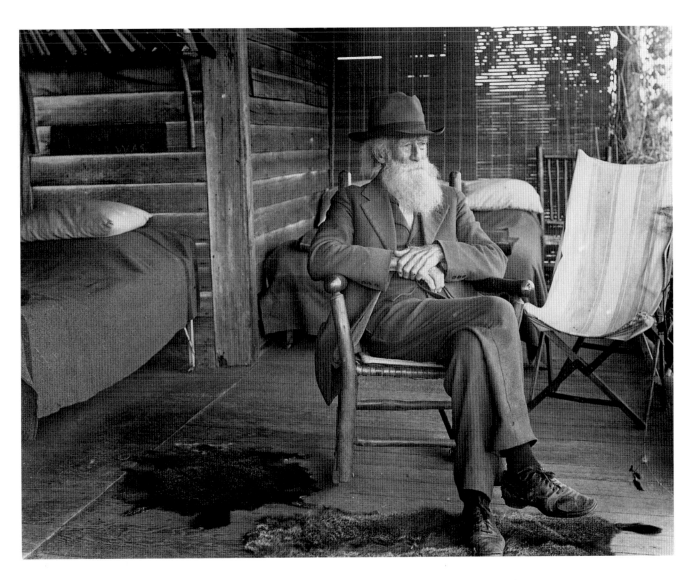

Burroughs sits on the porch at Woodchuck Lodge. At his feet are the skins of woodchucks.

NEXT PAGES: *"The peace of the hills is about me and upon me,"* Burroughs wrote from Woodchuck Lodge, *"and the leisure of the summer clouds, whose shadows I see slowly drifting across the face of the landscape, is mine."*

State Assembly. It read, in part, "Whereas press dispatches today announce the death of John Burroughs, foremost naturalist of the United States, and of late years a resident of La Jolla, San Diego County, therefore be it resolved . . . that in the death of John Burroughs the State of California, and the nation generally, have sustained the loss of one who, as a scientist, citizen and man, occupied a deservedly high place in the regard of the people. . . ."

Across the Atlantic in London, *The Times* ran a prominent obituary. It recalled the "rapturous welcome" that English readers had given Burroughs's books and noted that Burroughs had a "gift" to write about nature "without personification, in a form that seemed to cajole scientific truth into poetical moralization."

At day's end, *The New York Evening Post* likened the death of Burroughs to "the crash of some patriarchal pine towering above a younger forest."

It is April 3, 1921, Burroughs's eighty-fourth birthday. The sun shines. Birds sing. In a sloping Catskill meadow where Burroughs worked and played as a boy, the grass is soaked with dew. Underfoot, the soil, hard as iron a few days before but now thawed, shapes itself like potter's clay around the feet of the assembling mourners.

One of the mourners is Henry Ford. En route to the Catskills, Ford had told a *New York Times* reporter, "This is one of the saddest journeys of my life." Beside Ford stands Thomas Edison, and beside Edison stands Harvey Firestone. There are numerous others—Burroughs's son, Julian, and Julian's children, and a contingent of nieces, nephews, and neighbors.

Just uphill from the open grave, a gray boulder rises from the greensward. Spattered with colonies of gray-green lichen, the rock is rounded on the edges and resembles, in size and shape, a modern-day Volkswagen. As a boy, with a dog in tow, Burroughs often stole away to this rock to rest on its sun-warmed hump and gaze into the valleys below. The rock was a splendid place for an imaginative boy to think, to philosophize, and to dream of the years ahead. Later, it became an old man's focal point of reminiscence.

The burial service begins. Brahms's Lullaby is played, and the Twenty-third Psalm is read aloud. The scripture reading is an ironic parting touch for a man who was rarely seen in churches and who believed devoutly that the deity portrayed in the Bible was merely a reflected image of human longings. A passage from Isaiah follows. Now the words seem appropriate: ". . . the mountains and the hills shall break forth before you into singing, and all the trees of the field shall clap their hands." There are poetry readings. First is an excerpt from Walt Whitman's "Song of Myself." It is followed quickly by John Russell McCarthy's "The Still Trees" and "Youth," verses from Robert Louis Stevenson and Frank Talbot, and four poems that had been penned by contemporary authors in Burroughs's honor.

The valedictory—the final tribute before the mourners disperse—is a poem by Burroughs's longtime friend Myron Benton. The words are poignant. They set tears flowing afresh. They are the perfect send-off for a man who was dedicated to the proposition that events in the universe, harsh as they sometimes seem, are always for the best. Benton's poem concludes: "Oh God! is there another world so sweet?"

In old age, Burroughs continued to form friendships read-
ily. Here he sprawls on a pile of hay with John Russell
McCarthy, a poet who visited him at Woodchuck Lodge.
Burroughs frowned on much early twentieth-century
poetry—his last essay, "The Reds of Literature," con-
demned free verse—but he admired McCarthy, whose
poems rhymed.

Burroughs Reconsidered

In the late twentieth century, among active forms of recreation, nature study is more popular than baseball, football, and tennis combined. According to recent estimates, more than 80 million Americans watch birds, and they spend more than $14 billion annually on birdseed, nesting boxes, feeders, baths, binoculars, books, and travel. Impressive as these figures are, they are not comprehensive. In the woods, meadows, deserts, prairies, and oceans of the world, bird-watchers are joined by hordes of avocational botanists, herpetologists, mammalogists, nature photographers, whale watchers, mycologists, entomologists, and others with particular interests. "Ecology" is a buzzword among children and adults. Around the world, national parks, established as reservoirs of solitude, serve as meeting places for movie stars and heads of state. To sleep in the woods at Yellowstone and Yosemite, it is often necessary to reserve a campsite more than a year in advance. No suburban town is complete without a "nature center."

The nature study movement is a juggernaut. Among the men and women who helped to get it rolling, Henry Thoreau, John Muir, Rachel Carson, and a few other proponents of conservation and the simple life stand out. But the single greatest push may have come from the writing of John Burroughs. As Paul Brooks observed in *Speaking for Nature* (Houghton Mifflin, 1980), Burroughs made more converts to nature appreciation than anyone else, and "they and their successors have been fighting our conservation battles ever since."

If I were asked to bestow a single honorific upon Burroughs, I would call him the Father of Recreational Nature Study. Unlike Thoreau, who used nature as a rock from which to mine ethical principles, and Muir, who sang of the sublime beauty of wilderness, Burroughs looked upon the natural world as a source of simple joy. In his essays and poems, he encouraged his readers to venture afield for themselves, and to seek the same kind of intimate encounters with plants, animals, and landscapes that had made his own life so full and satisfying. He wrote with beguiling self-effacement, aiming to inspire and cajole rather than to correct and

Elizabeth Burroughs Kelley at the desk in her grandfather's Bark Study.

criticize. For Burroughs, life was an emotional struggle, and in his writings he shared that struggle (and his successes in it) with readers. This openness, a rare quality in a writer of any era, gave Burroughs and his books an appealing veracity. It also won him a legion of devoted converts. One was the ornithologist Frank Chapman, a staff scientist at the American Museum of Natural History in New York. In a memorial tribute to Burroughs, Chapman wrote, "His books helped to acquaint me not only with nature but with myself."

Burroughs's influence was sometimes indirect. For example, in the late nineteenth century, accurate popular books on wildlife identification were scarce. Naming a bird or flower usually required hours of scrutinizing a scientific tome that lacked illustrations and approached the size and weight of a big city telephone directory. Burroughs suggested the need for handy reference manuals, the sort of compact books we know today as "field guides." "One of these days," he wrote in 1891 in the popular periodical *St. Nicholas*, "some one will give us a handbook of our wild flowers, by the aid of which we shall all be able to name those we gather without the trouble of analyzing them." Burroughs thought the book would best be organized not like existing manuals, which arranged species according to their suspected evolutionary relationships, but according to obvious features such as color, habitat, and time of blooming. In this way, Burroughs opined, botany would be made inviting.

Mrs. William Starr Dana, an accomplished amateur botanist, read Burroughs's words and accepted the task as her own. Two years later, in 1893, Scribner's published her book *How To Know the Wildflowers*, a pioneering work. The book contained numerous illustrations and arranged the flowers described in its text according to their colors. Lest anyone doubt the identity of her muse, in the frontispiece Mrs. Dana quoted

Burroughs's call for books along the lines of her own. The book was a hit and is still in print today. Theodore Roosevelt hailed *How To Know the Wildflowers* as "so exactly the kind of work needed for outdoor folks who live in the country but know little of systematic botany, that it is a wonder no one has written it before." In the century since its printing, Mrs. Dana's manual has been much imitated. Popular field guides to nearly every plant and animal group are sold in bookshops today, and they all mimic the sensible, easy-to-follow plan of *How To Know the Wildflowers*.

Described by the distinguished author and editor Paul Brooks as "the least jealous of writers," John Burroughs did much to promote critical and popular respect for all nature writing. He introduced American readers to the works of the English naturalist Gilbert White, encouraged John Muir to put his passion for the western wilderness in books, criticized the nature writers whom he felt were undermining the credibility of the genre by peddling fictional field observations as fact, and, at a time when Henry Thoreau was little celebrated, wrote essays arguing that Thoreau was a great figure in American literature. Burroughs took issue with Thoreau on a few points of natural history but always made clear his conviction that Thoreau was the supreme American nature writer. "He drew a gospel out of the wild," Burroughs wrote of Thoreau. "He brought messages from the wood gods to men; he made a lonely pond in Massachusetts a fountain of the purest and most elevating thoughts."

As a naturalist, Burroughs helped to close the curtain on one era and open it on another. He began his studies according to the traditions of the century in which he was born, carrying a gun, shooting the creatures that interested him, examining their corpses in minute detail, and stuffing them as specimens. But as Burroughs watched the passenger pigeon vanish and

A female cardinal. Burroughs's secret of success as an ornithologist, he felt, was his love of birds. "You must have the bird in your heart," he wrote, "before you can find it in the bush."

LEFT: Golden ragwort blossoms brighten a patch of the forest floor along the fringe of the Slabsides swamp.

Burroughs often sat on this rock in a quiet corner of the
family farm, gazing into the distance and reflecting.

saw his Catskill forests cut down to provide bark for tanneries, his outlook changed. He recanted his old views and advised his legion of readers to swap their rifles for opera glasses, to devote themselves not to the scrutiny of anatomical minutiae but to solving the mysteries of animal behavior. And like his friend and contemporary John Muir, he began to view "progress" as a mixed blessing. Lamenting that man was "exhausting the coal, the natural gas, the petroleum of the rocks, the fertility of the soil," Burroughs warned readers that "we live in an age of iron and have all we can do to keep the iron from entering our souls."

As Burroughs grew older, he became more of an optimist. While other nature writers were beginning to hint, or state directly, that man was a sort of planetary disease, Burroughs grew more strident in suggesting that *Homo sapiens* was a sort of god, a supreme observer and appreciator without whom the world would lack meaning. "Man is not only as good as God," he wrote. "Some men are a good deal better, that is, from our point of view; they attain a degree of excellence of which there is no hint in nature—moral excellence."

Burroughs's essays on nature, literature, religion, and philosophy converged upon a single practical idea. Man needs to think more of himself, not less. He needs to enjoy the world if he is to care about saving it, to love himself if he is to remain a viable species through the ages. As Burroughs saw it, bird-watching, identifying flowers, climbing mountains, living simply, and working hard in the open air were all means toward this end.

At the American Museum of Natural History in New York, the John Burroughs Association meets each year on the third of April to celebrate Burroughs's birthday. A members meeting is held and officers are

A spiderweb glistens with beads of dew. In southern California, his health failing, Burroughs spent the winter of 1920–21 reading, resting, and studying the spiders that lived near the cabins he rented at La Jolla and Pasadena Glen.

NEXT PAGES: *On a cool autumn day, the John Burroughs Association meets at Slabsides. Visits by outsiders to the cabin have always been frequent. For example, between 1897 and 1920, the last full year of Burroughs's life, nearly seven thousand names were recorded in the Slabsides guest book.*

elected, but the day's chief order of business is awarding nature writing's most prestigious honor, the John Burroughs Medal. The list of winners is a virtual catalog of the great nature writers of the twentieth century. Among them are William Beebe, Ernest Thompson Seton, Joseph Wood Krutch, Roger Tory Peterson, Rachel Carson, John Terres, Paul Brooks, Ann Zwinger, and Peter Matthiessen.

The John Burroughs Association (formerly known as the John Burroughs Memorial Association) was founded shortly after Burroughs's death. Aside from

administering the Burroughs Medal, the group's chief function is maintaining Slabsides, which looks much the same today as it did in Burroughs's time. Iron gratings have been put over the windowpanes for security, but the rustic furniture Burroughs built with his own hands still occupies the house. A Vassar banner hangs on one wall, and old pieces of china given to Burroughs by his mother rest in honored places in the corner cupboard. Upstairs you can see the bed where John Muir slept, and below, by the hearth, one can sit in a wooden chair and gaze out the window into the celery swamp, as Theodore Roosevelt did one hot July day in 1903. At Slabsides, the presence of John Burroughs is palpable. Twice a year, on open house days in May and October, visitors are allowed inside.

A bronze plaque fixed beside the door attests that Slabsides is a National Historic Landmark. A similar honorific is bolted to the siding of Woodchuck Lodge. Unlike Slabsides, Woodchuck Lodge is still owned by Burroughs descendants. They use it as a summer home, as Burroughs did. To protect their privacy, the family invites visitors inside only on special occasions.

For anyone familiar with the life and the writings of John Burroughs, it is a rare pleasure to walk up the earthen road that leads from Woodchuck Lodge to the old Burroughs homestead. Along the shoulders one

Along the earthen road that passes through the old Burroughs farm in Roxbury, one can find this graffito acknowledging a 1914 gift from Henry Ford. Burroughs had wanted to add the pasture beyond this rock to his landholdings but lacked the capital needed to do so. Learning of the situation, Ford supplied his friend with the funds.

The body of John Burroughs lies here, in a high pasture on the old Burroughs family farm in Roxbury.

sees the stone fences that Burroughs and his brothers built by hand, the same fences which harbored the chipmunks that raided Burroughs's vegetable garden. On the left is an old orchard, a place where Burroughs often wandered in search of fruit and inspiration; and beyond, a pile of rocks buried under a tangle of weeds. Barely visible now, the rocks once served as the foundation beneath the "haybarn study," the office where Burroughs, at the peak of his celebrity, sat in the door-way of an open loft and penned essays on a writing desk fashioned from an old wooden crate. A little further along, a rock ledge juts from an embankment on the right and tumbles down to meet the road. If it is autumn, you will want to take your hand and sweep away the maple leaves that cover this rock. Beneath you will find a Burroughs graffito, etched with a chisel. There is a sketch of a human hand with the forefinger extended, the initials "J.B." and, as an epigraph, "The

TOP: *Among the wildflowers of early spring, Burroughs was most fond of the hepatica. "There are many things left for May," he wrote, "but nothing fairer than, if as fair as, the first flower, the hepatica."*

A box turtle browses for plants and earthworms in a Hudson Valley meadow. Burroughs described himself as "local as a turtle" because he traveled far from home rarely, and only with great reluctance.

Ford Lot." The carving was Burroughs's way of thanking Henry Ford for helping him to purchase a nearby pasture.

A few more strides and you come to a saddle, a place where the road crests before dropping on the opposite side. Here, to the left, you see a grove of trees separated from the road by a forest of "No Trespassing" signs. Beyond lie the beech woods, the place where Burroughs as a boy saw great flocks of passenger pigeons descend from the autumn sky to feast upon fallen beech nuts. Directly across the road, a zigzag cattle gate in a fieldstone wall opens into a sloping meadow. You can walk through the gate and into the meadow, which is owned and maintained by the State of New York as a Burroughs memorial. Walk up the hill and you come to an enormous round boulder, covered with lichen, where as a child Burroughs used to sit, think, and daydream. On the face of the boulder a plaque has been mounted. It shows Burroughs in bas relief and quotes "Waiting," the poem he wrote during his short-lived career as a medical student. A few feet downslope from the boulder, a knee-high stone wall built in the shape of a rectangle marks Burroughs's grave. If you visit in the month of May, you can stand at the gravesite, look across the valley to hills and mountains that form the backdrop to Burroughs's essays, and from the woods behind you hear the soft, dreamy trills of black-throated blue warblers, which still nest on the mountain Burroughs called Old Clump.

It is only a short walk now to the old Burroughs homestead. Beyond the beech woods and the gate leading to the memorial field the road descends toward a shallow gully. On both sides of the road, green pastures, no longer groomed by dairy cows but still cut for hay, provide homes for grasshoppers, goldfinches, and woodchucks. A low point is crossed and a ramshackle

barn stands on the right. Just beyond the barn is the house.

At present, the Burroughs homestead is owned by two retired college professors. Because the owners, a married couple, enjoy the privacy of their rural surroundings, and because the interior of the house is much changed from its appearance in Burroughs's day, there are no tours. But the house stands, as it has for nearly a century and a half, occupying a commanding position on the flank of Old Clump. And it continues to overlook the snug, green corner of the Catskills, with its pastures and woodlots, its mountains and valleys, that for John Burroughs provided the raw materials, and the inspiration, for a long and satisfying life.

Author and critic Henry James admired Burroughs's genius for natural observation. "When vivid color is wanted," Burroughs wrote, "what can surpass or equal our cardinal-flower? There is a glow about this flower as if color emanated from it as from a live coal."

Chronology

1837: Burroughs born, April 3, Roxbury, New York.

1854: Leaves home, begins teaching at Tongore; on May 30, occasional entries in notebooks begin.

1855: Spends winter studying at Hedding Literary Institute.

1856: Spends spring studying at Cooperstown Academy. May 13, first article published. Moves to Illinois in autumn.

1857: Turns twenty. Returns to New York, marries Ursula North on September 12. Teaches at High Falls, New York.

1859: Teaches at Newark, New Jersey. Contributes articles to *Saturday Press.*

1860: In November, the *Atlantic Monthly* publishes "Expression."

1861: Begins writing pieces for the *New York Leader.*

1863: Meets Ralph Waldo Emerson. Quits teaching, moves to Washington, D.C. Meets Walt Whitman.

1864: January 8, begins work at United States Treasury.

1867: Turns thirty. *Notes on Walt Whitman as Poet and Person* published.

1871: *Wake-Robin,* Burroughs's first volume of nature essays, appears in print. First trip to England.

1872: December 31, resigns job at Treasury Department.

1873: January 1, becomes bank receiver in Middletown, New York. Begins building house on farm near West Park, New York.

1874: Moves into new house, which he later names Riverby.

1875: *Winter Sunshine* is published.

1876: Begins journal on May 13.

1877: Turns forty. *Birds and Poets* is published.

1878: Julian Burroughs is born.

1879: *Locusts and Wild Honey* is published.

1881: Builds the Bark Study.

1882: Second trip to England.

1884: *Fresh Fields* is published.

1885: Burroughs's work as a bank receiver ends. From this point on, Burroughs is a full-time writer and farmer.

1886: *Signs and Seasons* is published.

1887: Turns fifty.

1889: *Indoor Studies* is published.

1892: Walt Whitman dies.

1894: *Riverby* is published.

1895: Builds Slabsides. Edits Gilbert White's *Natural History of Selborne.*

1896: *Whitman: A Study* is published.

1897: Turns sixty.

1899: Harriman Alaska Expedition.

1900: *The Light of Day* is published.

1901: Edits *Songs of Nature* (poems). *Old John Burroughs,* by Elbert Hubbard, is published.

1902: *Literary Values* and *Life of Audubon* are published. Travels to Jamaica.

1903: Nature faking controversy begins. Yellowstone trip with President Theodore Roosevelt, who also visits Slabsides in July.

1904: *Far and Near* is published.

1905: *Ways of Nature* is published.

1906: *Bird and Bough* (poems) is published.

1907: Turns seventy. *Camping and Tramping with Roosevelt* is published.

1908: *Leaf and Tendril* is published. Renovates Woodchuck Lodge.

1909: Travels with John Muir. Surfs at Waikiki.

1910: Accepts honorary doctorate at Yale.

1911: Accepts honorary doctorate at Colgate.

1912: *Time and Change* is published. *Rambles with John Burroughs*, by R.J.H. De Loach, appears.

1913: *The Summit of the Years* is published. Meets Henry Ford.

1914: Visits Ford and Thomas Edison in Florida. *Our Friend John Burroughs*, by Clara Barrus, is published.

1915: *The Breath of Life* is published. Accepts honorary doctorate at University of Georgia.

1916: *Under the Apple Trees* is published. Burroughs presented with a gold medal by the American Institute of Arts and Letters.

1917: Turns eighty. Trip to Cuba with Henry Ford. Ursula Burroughs dies.

1919: *Field and Study* is published.

1920: Turns eighty-three. *Accepting the Universe* is published. *John Burroughs, Boy and Man*, by Clara Barrus, appears.

1921: Dies March 29 on a train in Ohio. *Under the Maples* is published posthumously. *The Seer of Slabsides*, by Dallas Lore Sharp, appears.

1922: *The Last Harvest* and *My Boyhood* are published posthumously. *John Burroughs Talks*, by Clifton Johnson, appears.

1924: *The Real John Burroughs*, by William Sloane Kennedy, is published.

1925: *The Life and Letters of John Burroughs* (2 vols.), by Clara Barrus, is published.

1926: First John Burroughs Medal in nature writing awarded to William Beebe.

1928: *The Heart of Burroughs's Journals*, edited by Clara Barrus, and *The Boy's Life of John Burroughs*, by Dallas Lore Sharp, are published.

1930: *The Religion of John Burroughs*, by Clifford Hazeldine Osborne, is published.

1931: *The Slabsides Book of John Burroughs*, edited by H. A. Haring, and *Whitman and Burroughs, Comrades*, by Clara Barrus, are published.

1951: *John Burroughs's America*, edited by Farida Wiley and illustrated by Francis Lee Jaques, is published.

1959: *John Burroughs: Naturalist*, by Elizabeth Burroughs Kelley, is published.

1968: The Bark Study, Slabsides, and Woodchuck Lodge are named National Historic Landmarks.

1974: *John Burroughs*, by Perry Westbrook, is published.

1976: *The Birds of John Burroughs*, edited by Jack Kligerman, is published.

1978: Bard College in Annandale, New York, holds "A Symposium in Honor of John Burroughs."

1982: Vassar College purchases the Burroughs journals.

1983: Vassar and the State University of New York at New Paltz sponsor a John Burroughs symposium.

1987: *A Sharp Lookout*, nature essays by Burroughs, edited by Frank Bergon, is published by the Smithsonian Institution Press. New York State names the Catskill peaks Slide, Wittenberg, and Cornell "The Burroughs Range."

1992: *John Burroughs: An American Naturalist*, by Edward Renehan, Jr., is published.

Note: Page numbers in *italics* refer to illustrations; captions are indexed as text. Titles refer to works by Burroughs unless otherwise noted.

academic establishment, 102
Accepting the Universe, 129
adder's tongue, *44*
Adirondacks, 44, 49, *50–51*, 99, *100–101*
"Adirondacks, The," 52
Alaska expedition, *78*, 86, 90, 102, 107
Allen, E. M., 40, 42, 44
"All Souls" (pseud.), 40
American Institute of Arts and Letters, 116, 118
American Library Association Booklist, 124
American Museum of Natural History, 83, 108, 110, 126, 132, 136, 144, 147
American News Company, 46
American toad, *102*
Angell, Anna, 63–64, 71
"Apple, The," 57
apple-cutting bees, 33
arbutus, *37*
Ashland, N.Y., 36, 38
Atlantic Monthly, The, 40, 46, 52, 90
Audubon, John James, 42, 102
Audubon, John James, 99, 102
"August Days," 103
automobiles
 Ford gifts, 110, 113, 135
 JB as driver of, 113, *114*
autumn, 23, *24–25*, 33, 118, *120–21*

bald eagle, 103
bank examiner, 53, 54, 61, 64, 70
Bark Study, 66, *69*, 80, *143*
"Barn-Door Outlook, A," 119
barred owl, *91*
Barrus, Clara, 126, *127*, 135, 136
 as JB's biographer, 63, 113,
 as JB's editor, 99, 113, 126
 JB's relationship with, 97

Barrus, Eleanor, 135, 136
Barrus, Harriet, 126, *127*, 135, 136
basswood trees, *20*
Beebe, William, 147
bees, 18, *22*, 31, 110, *130*
Benton, Joel, 60
Benton, Myron, *41*, 42, 49, 57, 60, 64
 camping trip, 44
 JB tribute by, 141
Bergson, Henri, 125
"Birch Browsings," 52–53
birch trees, 126
Bird and Bough, 93, 103, 107
"Bird Life in Winter," 103
birds, 31, 42, 52, 98, 135, 145; *see also specific birds*
Birds and Bees, 75
Birds and Poets, 60
birds' nests, 103, 122, *134*
Black Creek, 54, *55*
black-throated blue warbler, *20*, 31, 152
bloodroot, 46
Bloomville Mirror, The, 38
bluebird, 46, *93*, 103, 126
"Bluebird, The," 93, 107
blue flag iris, *29*
blue jay, 72
Bolles, Frank, 97
Boston Transcript, The, 129
botany, 42, 144; *see also specific plants*
box turtle, *152*
Brahms's Lullaby, 135, 140
Breath of Life, The, 122, 124
Brewster, William, 83
brigand steaks, 126, *127*
Brooks, Paul, 142, 144, 147
Browne, Francis Fisher, *123*
Bryant, William Cullen, 68
Buffalo Grove, Ill., 38
bumblebees, *22*, 31
burdocks, 124
Burroughs, Amy Kelly (mother), 15, *19*, 33
 background and character, 16
 berrying, 16, 31
 death, 66
 farm chores, 18, 22–23
 grave, 64, *65*

Burroughs, Chauncey (father), *19*
 background and character, 15, 18
 butter sales, 33
 death, 66
 as farmer, 15–16, 18
 grave, 64, *65*
 and Julian's origins, 71
 politics, 15–16
Burroughs, Curtis (brother), 16, 38, 115
Burroughs, Eden (brother), 115
Burroughs, Eden (grandfather), 15
Burroughs, Elizabeth (granddaughter), *see* Kelley, Elizabeth Burroughs
Burroughs, Ephraim (great-grandfather), 15
Burroughs, Hiram (brother), 16, 83
Burroughs, Jane (sister), 16, 115
Burroughs, John
 birth, 12
 birthday celebrations, 90, *115*, 130, 132
 burial service, 140–41
 celebrity, 108, 129
 childhood, 16, 18, 22–23, 27, 31
 chores, 18, 22–23, 31, 33
 and controversy, 99, 102
 death, 136
 education, 22, 23, 27, 31, 36, 38
 as father, 63–64
 Father of Recreational Nature Study, 142
 and girls, 23, 33
 grave, *151*, 152
 health, 61, 83, 126, 132, 135, 136
 honorary doctorates, 108
 marriage, *see* Burroughs, Ursula North
 mood swings, 135–36
 obituaries and eulogies, 136, 140–41, 144
 philosopher, 40, 70–71, 73, *94*, 129–30, 147
 photographs of, *38, 39, 67, 74, 76–77, 78, 87, 94–95, 98, 106, 109, 111, 115, 117,*

118, 127, 128, 129, 132–33, 136, 137, 141
 poetry by, 90, 99, 103, 107
 popularity, 110
 productivity, 99, 118, 126
 schools named for, 129
Burroughs, John (grandson), 116
Burroughs, Julian (son), *62*, 83, 99, 132, 140
 adoption, 63–64, 71, 73
 at Harvard, 83, 102
 parents' peacemaker, 80, 116
 travel, 68, 102
Burroughs, Olly Ann (sister), 16, 23
Burroughs, Rachel Avery (grandmother), 15
Burroughs, Ursula (granddaughter), 116, 126, 136
Burroughs, Ursula North (wife), *39, 116*
 away from JB, 44, 54, 61, 63, 80
 and Barrus, 99
 death, 116, 118
 health, 52, 116, 118
 hospitality, 61
 infertility, 61, 63
 and Julian, 63–64, 71, 73
 marriage, 38
 squabbles with JB, 71, 80
 temperament of, 63, 83, 116
 travel, 68
Burroughs, Wilson, 16
Burroughs memorial meadow, 152
Burt, Mary, 75
butter
 making, 22–23, 31
 selling, 15, 18, 33
Buttermilk Falls, N.Y., 41, 42

California, 126, 129, 135, 136, 147
camping expeditions, 44, 64, *98*, 110, *113*, 126
cardinal, *145*
cardinal-flower, *153*
Carlyle, Thomas, 53
Carolina wren, *130*
Carpenter, Edward, 60

Carson, Rachel, 142, 147
Caswell, Emma, 62, 63
Catskill, N.Y., 33
Catskill Mountains, 12, 79, 115, 116, 153
celery patch, 76–77, 82, 83
cemeteries, 27, *30*, 35, 64, *65*
Chapman, Frank, 83, 93, 144
Chase, Salmon P., 45
children, 108, 110, 122, *129*, 130, 132
 anthology for, 75
chipmunks, 33, 122
Chloe (cow), 45, 46, 60
"Civil Disobedience" (Thoreau), 57
Civil War, U.S., 44, 45, 46
Clearwater, A. T., 63
clothing, homemade, 18, 126, *127*
Colgate University, 108
columbine, *29*
conservation, 79, 97, 147
Cooperstown Seminary, 38
cows, 15, 18, 22, 31, 45, 60, *61*
crinkle-root, 23
crows, 33, *103*, 107, 126
Cuba, 118
Curtis, Edward, 86

Daily Times, The (Los Angeles), 140
Dall, William H., 86
Dana, Mrs. William Starr, 144
deer, 96, 97
De Loach, Richard, 113
Deyo place, 54
Dial, The, 123, 129
"Divine Abyss" (Grand Canyon), 107
dogs, 23, 66, *74*, *117*
dogtooth violet, *4*
Double Top Mountain, 79

eagles, 103
East Orange, N.J., 40
ecology, 142
Edison, Thomas A., *112*
 camping trips, 110, *112*, 113, 126
 on JB, 136
 JB on, 110
 at JB's burial service, 140
Emerson, Ralph Waldo, *43*, 60, 64
 JB compared to, 40
 as JB's hero, 43, 44
 on *Leaves of Grass*, 44
England, 53, 82, 140

Esopus River, *92*, 93
Esopus Valley, 107
Evening Transcript (Boston), 136, 140
"Expression," 40

farm
 absentee landlords, 15–16
 chores, 15, 16, 18, 22–23, 31, 33, 38, 41
 crops, 15, 18
 JB's early home, 12, *14*, 15–18
 JB's return to, 116, 119
 kitchen, 18
 life, 18, 22–23, 31, 36
 meals, 18, 22, 23, 33
 road, 12, *13*
 today, 150–53
Far and Near, 102
Field and Study, 125–26, 129
field guides, 144
Firestone, Harvey, 110, *112*, 113, 126, 140
Fisher, Clyde, 132
fishing, 16, 27, 29, 31, 63, *92*, 93
flying squirrels, 116
Foraste, Anita, 132
Ford, Henry, *111*, *112*
 camping trips, 110, *112*, 113, 126
 Cuba trip, 118
 gifts from, 110, 135, *150*, 151–52
 JB on, 110
 at JB's burial service, 140
 Slabsides visitor, 80
Forest and Stream, 86
forests, 49, *50–51*, 147
"Fox, The," 54
foxes, 33, 126
"Fragments from the Table of an Intellectual Epicure," 40
free verse, 141
Fresh Fields, 68
frogs, *124*, 125
"From the Back Country," 41, 42
fruit, from Riverby, 75
Fuertes, Louis Agassiz, 86

Gannett, Henry, 86
geology, 118
Georgia, 113
Georgia, University of, 108
ghosts, fear of, 27, 35
goldfinches, 152

golfing, 22
"Gospel of Nature, The," 119
Grand Canyon, *106*, 107
grapes, *73*, 75, 82, 86
grasshoppers, 152
gray squirrel, *52*, 122
great blue heron, 23, *24–25*
Greenwich, Conn., Historical Society, 132
Grinnell, George Bird, 86

hair-cap moss, *125*
Harriman, Edward Henry, 86, 90
Harriman Alaska Expedition, *78*, 86, 90, 102, 107
Hawaii, 107, 108, 118–19
hawks, 33, 49, *83*
hay, haying, 15, *17*, 33, 36, 38, 152
hay-barn study, 119, 132
"Hazards of the Past, The," 119
"Heart of the Southern Catskills, The," 79
Hedding Literary Institute, 36
Henion, Amanda, *62*, 63, 64
hepatica, 46, *152*
hermit thrush, 49, 53
Hetch-Hetchy Valley, 115
Higginson, Thomas Wentworth, 67, 68
High Falls, N.Y., 38, 40
Holmes, Oliver Wendell, 60, 64
homes, of JB
 in East Orange, 40
 in High Falls, 38, 40
 in Washington, 45
 see also farm; Riverby; Slabsides; Woodchuck Lodge
honeybee, 110, *130*
Houghton, Oscar, 75
Houghton Mifflin, 99, 122
house wrens, 126
Howells, William Dean, 52
"How I Can Do More Work at 77 than at 47," 125
How To Know the Wildflowers (Dana), 144
Hubbard, Elbert, 96–97
Hudson River, 33, 54, 57, *58–59*, 79, *131*
Hugo, Victor, 73
Hull, Abram, 36, 41
hummingbird, *48*
Hunter Mountain, 12
"Hunt for the Nightingale, A," 68, 70

hunting, 33, 97, 144, 147
Hurd and Houghton, 52

income
 from butter, 15, 18, 33
 from maple sugar, 35, 132
 from royalties, 77
 from teaching, 36, 38, 40, 41, 42, 45
 from Treasury Department, 45
Indoor Studies, 73
industrial revolution, 71, 73, 147
"In the Hemlocks," 46, 49, 52, 53
investment, 40
"In Warbler Time," 125
iris, blue flag, *29*

Jamaica, 102
James, Henry, 57, 153
Jenny Brook, 130, 132
John Burroughs, Boy and Man (Barrus), 113, 115
John Burroughs Association, 147, *148–49*, 150
John Burroughs Medal, 94, 147, 150
"John O'Birds," 135
Johns, Aaron, 64
Josephson, Matthew, 110
journal entries
 on Edison and Ford, 110
 first, 57, 60, *68*
 on JB's health, 135
 on joy, 108
 on Julian, 71
 last, 135–36
 on Muir, 83, 115
 on wife's death, 118
 winter thoughts, 135

Keene Valley, N.Y., 49, *50–51*
Kelley, Elizabeth Burroughs "Betty" (granddaughter), 63–64, 71, 83, 116, *118*, *143*
Kelly, Edmund "Granther" (grandfather), 16, 27, 31
Krutch, Joseph Wood, 147

Ladies Home Journal, 125
La Jolla, Calif., 129, 135, 140
land conservation, 79
language, JB on, 40–41

Lark (dog), 66
Leaves of Grass (Whitman), 43, 44, 64, 84
ledges, 99, *100–101*
life
 as emotional struggle, 144
 joy of, 108, 130, 142
 miracle of, 124
Life and Letters of John Burroughs (Barrus), 63, 113
Light of Day, The, 99
lily, trout, *44*
Lincoln, Abraham, 46
Literary Values, 102
"Little Spoons vs Big Spoons," 73, 75
Lives of the Game Animals (Seton), 94
Locusts and Wild Honey, 64, 93
Long, William, 90–91, 93, 94
Lowell, James Russell, 60, 68
Lummis, Charles, 129

McCarthy, John Russell, 132, 140, *141*
McCulloch, Hugh, 45
"Malformed Giant, A," 73
maple sugaring, 31, 35, 38, 129, 130, *132–33*
maple trees, *34, 104*, 119, *120–21*
Marlboro, N.Y., 41
marsh hawk, *83*
"Master Instinct, The," 125
Matthiessen, Peter, 147
meadowlark, 46
medicine, 41
Merriam, Clinton Hart, 86
Merriam, Florence, 93
Middletown, N.Y., 53, 97
migration, 126
milking, 22, 31, 36
Model T Ford, 110, 113
moral excellence, 147
Mt. Graham, 79
mourning doves, *31*
Muir, John, 144, 147
 with Alaska expedition, *78*, 86, 90, 107
 Barrus on, 113
 death, 115
 in Grand Canyon, *106*, 107
 JB on, 83, 115
 and JB's birthday, 90, *115*
 JB's friendship with, 77, *78*, 79, 90
 and nature study movement, 142
 poem by, 90

Slabsides visitor, 80, 83, 150
 and wilderness preservation, 79, 115
Muir glacier, *78*
My Boyhood, 22, 27, 33

Napanoch, N.Y., 130
Nation, The, 57, 67
National Audubon Society, 125
Natural History of Selborne, The (White), 52, 82
"Nature and the Poets," 67–68
nature essay, JB as master of, 53, 57, 136, 140
nature faking controversy, 90–91, 93–94, 126
nature study movement, 142, 147
nature-worship, 129
Neversink River, 64
Newark, N.J., 40, 41
"New Gleanings in Old Fields," 103
New York Evening Post, The, 52, 140
New York Leader, 41, 42
New York State Legislature, 97
New York State Senate, 136
New York Times, The, 86, 107, 124, 129, 140
nightingale, 68, 70
North American Review, The, 93, 124
notebooks, 36, 38, 40; *see also* journal entries
Notes on Walt Whitman as Poet and Person, 43, 46, 49

Old Clump, 12, 16, 27, 152, 153
Older, Seymour, 31, 131
Old John Burroughs (Hubbard), 96–97
Old Stone Jug, 22, 23, *26*
Olive, N.Y., 41
"Oom John," 96
orchids, pink ladyslipper, 45
Osborn, Henry Fairfield, 136
Our Friend John Burroughs (Barrus), 113, 122
"Our Rural Divinity," 60
Outdoor Pastimes of an American Hunter (Roosevelt), 96, 98
ovenbird, *134*
owls, 33, *82, 91*

Panther Mountain, 79
passenger pigeon, 18, 31, 60, 144, 152

Peak-o'-Moose Mountain, 79
"Pepacton," 66–67
Pepacton, 66–67, 75
Pepacton River, 64, 66
Peterson, Roger Tory, 147
Petrified Forest, 107
"Phantoms Behind Us, The," 119
"Philomath" (pseud.), 38
"Philosophy of the Porch, The," 38
phoebe-bird, 126
pigs, 15, 18
Pine Knot, Va., 115–16
Plain Dealer (Cleveland), 140
porcupine, 99
Psalm 23, 140

raccoons, 33
radical optimism, 129
ragwort, *145*
Rambles with John Burroughs (De Loach), 113
raspberries, 75
"Real and Sham Natural History," 90–91, 93
"Reds of Literature, The," 141
red squirrel, 122
redstart, 57, 60, 68
red-tailed hawk, 49
red-winged blackbirds, 40
religion, 99, 102, 129–30
reproductive urge, 125
Ridgway, Robert, 86
Riverby, *56*, 64, 97, 118, 129, 135
 Bark Study, 66, *69*, 80, *143*
 on Hudson River, 54, 57, *58–59*
 vineyards, 54, 64, *73*, 75, 79, 82, 83, 86
 visitors, 60, 61, 63, 80, 108
Riverby, 79
Roberts, Charles, 93
robin, 126
rock, 140, *146*
Rogers, Will, 129
Roosevelt, Theodore, 77
 as bird-watcher, 98
 camping trips, *98*, 99
 death, 115–16
 "His Transparency," 96, 115
 on *How To Know the Wildflowers*, 144
 and nature fakers, 94, 96
 Slabsides visitor, 80, 96, 150
Rosendale, N.Y., 40

Roxbury, N.Y.
 family farm, *see* farm
 JB's early years in, 16, 18, 22–23, 27, 31
 JB's grave, *151*, 152
royalties, 77
Roycroft Shop, 96

Sagamore Hill, 115
St. Nicholas, 144
salamanders, 125, *125*
Saturday Press, The, 40
saw-whet owl, *82*
schoolhouse, 22, 23, *26*
School of the Woods (Long), 93
schools, JB's essays in, 75
science, 119
"Scientific Faith," 119
screech owls, 33
Scribner's, 60, 144
sculpture, 108, *109*, 110
Seaman, Frank, 130
segue, JB master of, 126
self-exploration, 16, 73, 119
self-love, JB on, 147
Seton, Ernest Thompson, 90–91, 93–94, 97, 126, 147
Shakespeare, William, 60, 66, 116
Sharp, Dallas Lore, 93
sheep, 15, 18, 23
 Dall, 86
shooting, 33, 97, 144, 147
Signs and Seasons, 29, 70–71
simple life, 71, 147
Skinner, Stephen, 97
Slabsides, 80–82, *84–85*, 86, 87, 88, 89, 135
 fireplace, 80, *81*, 82, *94–95*
 and John Burroughs Association, *148–49*, 150
 National Historic Landmark, 150
 visitors, 80, 83, 89, 96, 97, 108, *123, 128*, 129, 150
slate pencils, 20, 23
Slide Mountain, 12, 79
Smoky Mountains, 126
"Snow Walkers, The," 46, 54, 57
snowy meadow, *32*
"Song of Myself" (Whitman), 140
"Song of the Toad," 107
song sparrow, 126
sparrows, 126, *135*
Speaking for Nature (Brooks), 142
Specimen Days (Whitman), 61
spiders, 135, 147
spiderweb, *147*

spotted salamander, *125*
spring, 31, 57, *104, 105,* 126
squirrels, 18, *52,* 116, 122
Stafford, Harry, 60
Steel's Tavern, 33
Stevenson, Robert Louis, 140
"Still Trees, The" (McCarthy), 140
Stone, Mrs., 126, *127*
stone walls, *16,* 151
Stratton Falls, 20, *21,* 23, 64, 66
"Strawberries," 64
streams, 28, 29
sugar maples, *34,* 35, *104,* 119, *120–21*
summer, 22, 23, 27, *138–39*
Summit of the Years, The, 119, 122
sunflower, 97
surfboarding, 108

Table Mountain, 79
Talbot, Frank, 140
teaching, 36, 38, 40, 41, 42
Terres, John, 147
Thoreau, Henry David, 15, *42*
 JB compared to, 57, 75, 97, 136
 JB on, 73, 144
 and nature study movement, 142
thrushes, 46, 49, 53
Time and Change, 118–19
Times, The (London), 140
toads, *102,* 125
"To the Lapland Longspur," 107

Toledo, Ohio, 110
Tom Jones (Fielding), 80
Tongore, N.Y., 36, 118
toothwort, 23
Torrey, Bradford, 93
toys, 27
trapdoor spider, 135
travel writing, 66, 68, 99, 118–19
Treasury Department, U.S., 45–46, *47,* 49, 53, 70
Trelease, William, 86
trout lily, *44*
tufted titmouse, 48
tulip-tree, 72, *104*
turtle, 125, *152*

Under the Apple Trees, 125
universe, 102, 130

"Vagaries viz. Spiritualism," 38
Van Benschoten, Mr., 86
Vanderbilt mansion, *131*
Van Dyke, Henry, 97
Vassar College
 archives, 97
 banner at Slabsides, 150
 visitors from, 108, *128,* 129
Victrola, 132, 135
vineyards, 64, *73,* 75, 79, 82, 83, 86

"Waiting," 41, 42, 152
Wake-Robin, 49, 52–53

Walden (Thoreau), 15, 42, 57, 75
warblers, *20,* 31, 57, 60, 68, *134,* 152
Warner, Charles Dudley, 93
Washington, D.C., 40, 44, 45–46, 47, 53, 130
wasps, 126, 129
West Point, U.S. Military Academy, 42, 44
West Settlement School, 23, 27
"When Lilacs Last in the Door-yard Bloom'd" (Whitman), 49
White, Gilbert, 52, 73, 82, 144
whitetail deer, 96, 97
white-throated sparrow, *135*
Whitman: A Study, 83–84, 86
Whitman, Walt, *43,* 44–45, 49, 52, 70, 140
 Barrus on, 97
 Hubbard on, 97
 influence on JB, 46, 64
 JB compared to, 137, 140
 JB on, 43, 46, 49, 60, 83–84, 86, 122, 129
 JB's advice to, 49
 as JB's hero, 44, 84, 113
 sexual preference, 60
 visits to Riverby, 61, 63
"Whitman Land," 54, 83
Wild Animals I Have Known (Seton), 91
wilderness preservation, 79, 147
"Wild Life About My Cabin," 103

wildlife conservation, 97
Wiley, Farida, 126, *127*
Wilson, Woodrow, 115
winter, 16, 18, 31, *32,* 80, 135
Winter Sunshine, 54, 57
"With the Birds," 46
Wittenberg range, 79
wood-chopping contests, 110, 113
Woodchuck Lodge, *119, 120–21, 122,* 126, 132, 135, *137*
 built by Curtis, 115
 National Historic Landmark, 150
 visitors, 110, 132, *141*
woodchucks, 27, 33, 126, *127,* 129, 132, *137,* 152
wood frog, *124*
Wordsworth, William, 60
World War I, 126
worm-eating warbler, *134*
wrens, 126
writing, JB's thoughts on, 73, 82–83, *125*

Yale University, 108
Yama Farms, 130, 132, *132–33*
Yellowstone National Park, 94, 96, *98,* 99, 142
Yosemite Valley, 107, 115, 142
"Youth" (McCarthy), 140

zinnia, *130*
Zwinger, Ann, 147

Photo Credits

Courtesy The Jones Library Special Collections, Amherst, Massachusetts: 14 top, 74, 75, 76–77, 87, 117 (photos by Clifton Johnson)

The American Museum of Natural History, Courtesy Department of Library Services: 14 bottom (photo by Clyde Fisher), 19 left and right, 26 (photo by M.H. Fanning), 39 left and right, 41, 56 (photo by Clyde Fisher), 109, 114, 119, 123, 127 top (photo by Clyde Fisher), 129, 132–133 (photo by Clyde Fisher), 137 (photo by Clyde Fisher)

Library of Congress: 2, 42, 43 left and right, 47, 78, 94–95, 112 top, 115, 118, 136

Courtesy Elizabeth Burroughs Kelley: 62 left and right, 111

Courtesy H.B. Shatraw: 67, 106, 112 bottom, 116, 127 bottom, 141

Harvard College Library, Theodore Roosevelt Collection: 98

Vassar College Library: 128